THE WESTERN HIGHLANDS

SCOTTISH MOUNTAIN DRAWINGS

THE WESTERN HIGHLANDS

A Wainwright

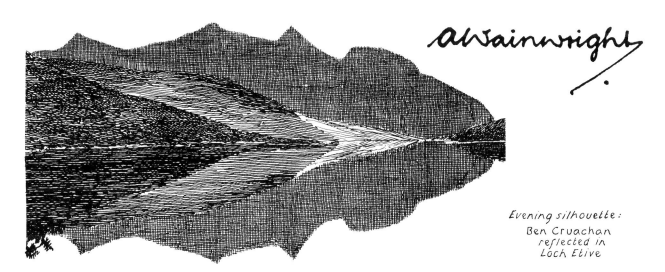

Evening silhouette:
Ben Cruachan
reflected in
Loch Etive

PUBLISHED by FRANCES LINCOLN, LONDON

PUBLISHER'S NOTE

The Western Highlands was originally published as Volume Three in a series of collections of Scottish mountain drawings. The drawings were numbered throughout the series rather than by individual volume, so the first drawing in The Western Highlands is number 151. The introduction to Volume One of the series – in which Wainwright explains the spirit in which the project was conceived – is reprinted in full on the pages immediately following this note.

Frances Lincoln Limited
4 Torriano Mews
Torriano Avenue
London NW5 2RZ
www.franceslincoln.com

First published by Frances Lincoln 2006
Originally published by Westmorland Gazette, Kendal, 1976

Printed and bound in Singapore

A CIP catalogue record is available for this book from the British Library.

ISBN 0 7112 2590 7

INTRODUCTION

The introduction to this book ought really to be prefaced by an apologetic explanation of the reason why a Sassenach, and a Lancashire Sassenach at that, should presume to offer a book about Scotland, and on a subject, moreover, so exclusively Scottish as the Highlands.

Well, it's like this. I have had two great ambitions in my life, and neither has been satisfied by achievement. One was to be the first man on the summit of Everest, and, after tormenting me for thirty years, this bubble burst on Coronation Day 1953. The other was to climb to the top of every Munro in Scotland, and this proved to be a pipe dream too. Everest, for me, was palpably unattainable; the Munros were a more practicable challenge but my plans never got off the low ground. I was fettered to a desk in England all my working life and although in my brief annual holidays I always headed north over the Border I could never resist the lure of a full tour around the mountains, by train and MacBrayne, rather than halt at the foot of one peak when so many were to be seen by moving on. I did the rounds year after year and had nothing to show except an album of a thousand photographs.

Retirement came in due course and with it a last opportunity, late in the day. Too late, alas. My mind had not lost enthusiasm but my legs had; and I was heavily committed with other work. I still went to Scotland, indeed more often, but only to admire, not to climb. More years went by thus. Then one day an idea stirred and quickly fanned into an aspiration..... If I couldn't climb all the 276 Munros, perhaps it wasn't too late, even yet, to visit them all, to track those I had never seen simply because they were too remote — not to climb them but to get myself to viewpoints where I could see them in perspective, and compile a collection of drawings of them. This is the pleasurable task I am engaged upon. I am getting rid of an itch.... So the reason for the book is a love of the Scottish Highlands.
 Now for the introduction proper.

In 1891 Sir Hugh T. Munro listed all the Scottish mountains over 3000 feet in altitude, classifying them in districts and in descending order of height, a total (revised) of 276, Ben Nevis, 4406', being number 1 and Càrn Aosda, 3003', number 276. Thereby he lit a flame — his Tables were published and became well known in mountaineering circles, the 276 mountains became commonly known as Munros and presented an obvious challenge that many climbers have accepted. 'Munro-bagging', 'collecting' Munros by ascending to their summits, is an esteemed sideline of Scottish mountaineering, a long-established ritual for dedicated enthusiasts. Sir Hugh compiled his Tables with such care that, although subjected to occasional minor revision, they remain substantially unchanged. The Tables (1969 edition) have been regarded as gospel, so far as details of altitude and precedence are concerned, in the preparation of this book, although recent issues of the 1" Ordnance map show corrections to the original heights of a few of the mountains and thereby call for further slight amendments. In this book a bracketed number following the title of a drawing of a Munro indicates the order of precedence in the Tables. For example (M.58) means a Munro and the 58th highest mountain listed in the Tables.

Difficulties arise in determining the correct spellings of many of the mountain names, which are almost invariably in Gaelic, different versions being in use in some cases. The Ordnance Survey spellings are often suspect and inconsistent but have been adopted in Munro's Tables and are therefore used in this book. Alternative spellings in general use are given in brackets under the titles of the drawings.

Mountain names in Scotland, unlike those in England, usually incorporate as a prefix an equivalent of 'mountain' but these too are variously spelt as Ben, Beinn and Bheinn. In many cases the name of a feature is substituted, thus Sgòrr, Sgùrr and Sgòr (= scar); Maol, Meall, Mheall, Meallan, Mam, and Maoile (hill); Stùc, Stac and Stob (peak); Bidean (little peak); Spidean (sharp peak or pinnacle); Creag (crag); Carn (cairn). Confusion is worse confounded by inconsistency in the accenting of vowels: More (big) appears also as Mor, Mòr, Mhor and Mhòr. An English climber in Scotland thinks affectionately and with nostalgia of the simple mountain names of his own Lake District: Helvellyn, Glaramara, Blencathra, Great Gable: lovely names, pronounceable and straightforward.

As regards pronunciation of Gaelic names the average visitor from south of the Border simply has to give up. When Chlaidheimh is pronounced Clay, A'Mhaighdean AA-vi-ee-chun, Choire Leith Horrie Lay and Ceathreamhnan Cerranan there is no hope for the unlearned — and ignorance suffers worse frustration when names that look ugly roll off a Highlander's tongue like sweet music. No attempt has been made to give pronunciations except for just a few of the better known mountains where there seems to be general agreement.

English translations of Gaelic names have been given where known, and freely adopted from the excellent guidebooks of the Scottish Mountaineering Club. But in the matter of interpretation, too, there is cause to wonder at the complexities of the language. For example, Beinn Bhàn, Sgùrr Bàn, Fionn Bheinn, Foinaven and Foinne Bhein all have the same meaning: "the white mountain." English translations are given in brackets, where known, following the titles of the drawings.

There is a crying need for a Royal Commission composed of Gaelic scholars and oldest inhabitants and Scottish mountaineers, with a representative of the Ordnance Survey also in attendance, to examine Highland nomenclature and agree upon (a) correct spellings, (b) correct pronunciations and (c) correct interpretations. This is not to suggest that Gaelic names should be Anglicized, far from it, but merely that bewildered visitors who like to wander amongst the Highlands should be let into the secrets of the language. When you have climbed a mountain it is nice to be able to say so and to say which, rather than avoid mention of the name because you cannot pronounce it.

In this book altitudes are recorded in feet, not the newfangled metres, and distances in Scottish miles, not foreign kilometres. You can't teach an old dog new tricks; some old dogs simply refuse to learn.

Mention has been made of the guidebooks of the Scottish Mountaineering Club. These are not only invaluable aids for the walker who tramps over the hills but have also very considerable merit as literature. The original editions in particular are written in prose that reads like poetry and were at the time absolutely accurate in all details; the later revised editions now current just lack that touch of class but are essential because of many topographical changes brought about by recent hydro-electric schemes and the resultant loss of certain paths.

To an artist with sketchbook or camera the Scottish mountains have helpful attributes: most of them are both photogenic and accommodating, scoring heavily over the English because they present themselves in much better perspective, their steepening concave slopes often rising sharply from flat ground and so permitting full summit-to-base views. To avoid a foreshortening effect a distance of about four miles is generally preferable if a viewpoint can be found that is not interrupted by intervening high ground, and a flat or descending foreground is an advantage in emphasising the stature of the subject. The ideal viewpoint is an opposite slope at rather less than mid-height with a valley between, looking along the line of a watercourse descending from the summit. Many good sightings are obtained from the vicinity of the motor roads with no more walking than is necessary to find an interesting foreground. If a fair distance needs to be covered on foot to bring a mountain into full view, advantage should be taken, if feasible, of the paths shown on the Ordnance maps: these, often made and maintained by stalkers, are invariably easy to follow and firm underfoot because they are not over-used. The crossing of rough flat ground in the Highlands without a path to guide can be a serious undertaking, consuming more time, burning up more energy and invoking more bad temper than climbing a steep slope..... And another most important and most endearing feature of the Scottish mountains is their usual clear visibility and freedom from haze. Bless them for that.

When a lover of the Highlands is too old to climb he can find compensation with a good camera and his tattered Ordnance maps and a copy of Munro's Tables. And a photograph album with 276 spaces. The Munros offer a different late-in-life challenge to the old-timer who can still cover ground on foot to bring them into view: he can 'do' the Munros in a new way, hunting them with his camera and filling the spaces one by one, and so bringing a rewarding fresh interest to his later years.

He will be a proud and happy man when the last space is filled.

AW
February 1974

THE DISTRIBUTION OF MUNROS (▲)
in the
WESTERN HIGHLANDS
(53 in total)

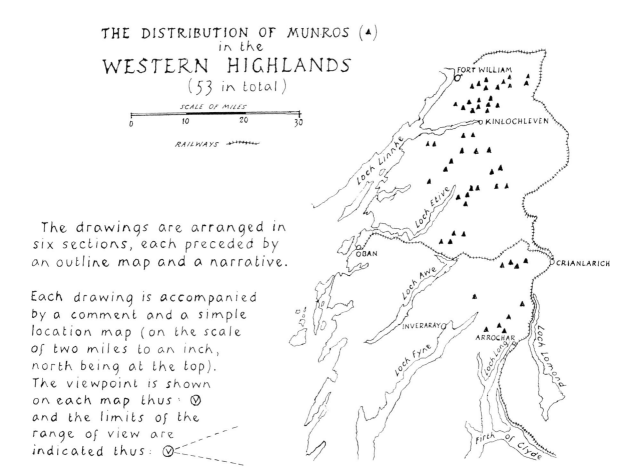

SCALE OF MILES

0 10 20 30

RAILWAYS ⨉⨉⨉⨉⨉⨉

FORT WILLIAM

KINLOCHLEVEN

Loch Linnhe

Loch Etive

OBAN

CRIANLARICH

Loch Awe

INVERARAY

ARROCHAR

Loch Fyne

Loch Long

Loch Lomond

Firth of Clyde

The drawings are arranged in
six sections, each preceded by
an outline map and a narrative.

Each drawing is accompanied
by a comment and a simple
location map (on the scale
of two miles to an inch,
north being at the top).
The viewpoint is shown
on each map thus: Ⓥ
and the limits of the
range of view are
indicated thus: Ⓥ

A bracketed number following the title of a drawing of a Munro indicates the
order of precedence in Munro's Tables. For example (M.58) = the 58ᵗʰ highest
mountain listed in the Tables.

THE DRAWINGS IN THIS BOOK

in the order of their appearance:

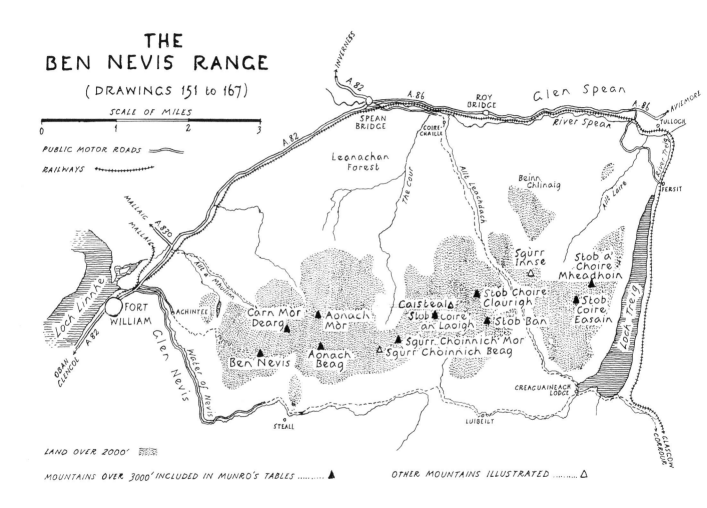

THE BEN NEVIS RANGE

(DRAWINGS 151 to 167)

SCALE OF MILES

0 1 2 3

PUBLIC MOTOR ROADS

RAILWAYS

LAND OVER 2000'

MOUNTAINS OVER 3000' INCLUDED IN MUNRO'S TABLES ▲ OTHER MOUNTAINS ILLUSTRATED △

That part of Lochaber lying between the head of Loch Linnhe and Loch Treig, referred to as Killiechonate Forest by the Ordnance Survey (but by few others), is one of the best-known tourist areas in the Highlands, the magnet being the highest mountain and the greatest landmark in the British Isles.

Ben Nevis rises to 4406 feet directly from sea-level, and, being isolated on three sides, reveals its full stature at a glance from many viewpoints. Yet to many visitors who come expecting to be enthralled by the sight of a tall and shapely peak, first impressions are disappointing. Here is no Matterhorn but a massive hill, rounded and undistinguished, often wreathed in mist and seeming to offer, apart from its superior altitude, little inducement to climb its obviously tedious stairway of stones. Its dominating height, however, is of fundamental importance to the thousands who annually, to satisfy a popular and commendable ambition — to get to the top of Scotland's highest mountain — make the treadmill trek to the summit. But there is another aspect to the character of this hoary monarch, for the symmetrical slopes that build up to its crest break suddenly into the most dramatic precipice in the Highlands: a truly awesome abyss of cliffs and buttresses cleft by fearful gullies, a place for expert cragsmen and no others. This vertical desert of rock, not seen from the usual tourist path, sets the seal on Ben Nevis as the greatest Munro of all.

Eastwards from Ben Nevis there extends for several miles a range of lofty summits of exceptional distinction, together making a formidable mountain barrier. Only by comparison with the Ben can these mountains be considered inferior, for many approach or exceed 4000 feet, and, in the absence of paths, their ascent calls for experience of rough and steep terrain. The two Aonachs are especially grand, towering spectacularly into the sky, and, further east, a high group known as the Grey Corries, characterised by light-coloured scree and finely-carved peaks, command attention although, being quite beyond the aspirations of ordinary tourists, their summits remain lonely. The range ends abruptly with a half-mile plunge into the waters of Loch Treig.

These mountains are extremely well defined in the north by the wide valley of the Lochy, to which they are magnificently displayed, and by Glen Spean, and in the south by the lovely defile of Glen Nevis. Visitors were brought to the area in numbers first by the West Highland Railway, and latterly new roads have greatly increased the influx. The historic old town of Fort William, the Zermatt of Ben Nevis, is thronged with crowds in summer, when, despite a rapid spate of new hotels, accommodation is often severely taxed. Spean Bridge and Roy Bridge, both with railway stations and catering for seasonal visitors, are quieter alternatives in pleasant surroundings.

The pilgrims to Ben Nevis are a motley crowd of young and old, fit and infirm, expert and novice, and invariably they make the ascent along the wide and well-trodden pony track constructed a century ago to serve an observatory on the summit. The ascent is too often under-estimated and weather conditions misjudged: many fall by the wayside and a few tragically perish. Ben Nevis is a mountain to be respected.

Happily for non-Gaelic visitors the mountain has derived a simple and lovely name from its Celtic origins. While scholars wrangle over Beinn Neamh-bhathais ("the mountain with its head in the clouds") and Beinn Nimh Uisg ("the mountain of biting cold water") the less erudite are perfectly content with Ben Nevis.

151 Ben Nevis, 4406' (M.1)

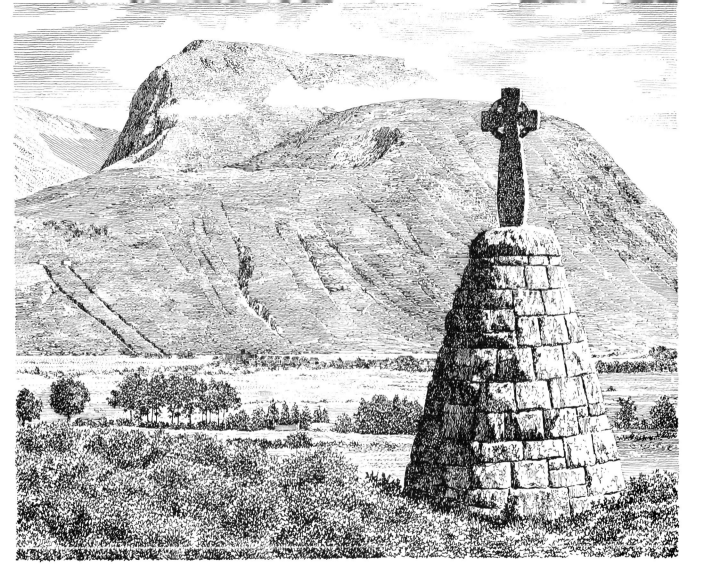

The most-favoured viewpoint for photographs of Ben Nevis is Corpach, perhaps because of the interesting foreground offered by the quaint buildings on the pier or by the war memorial (drawing 151), but is not wholly satisfactory from here because the view includes only the merest suggestion of the great north-eastern cliffs that give the mountain its principal distinction. Moving eastwards from Fort William, these cliffs come splendidly into sight at Torlundy. Although partly obscured by intervening foothills, enough is seen of them to give an appreciation of their splendid architecture.

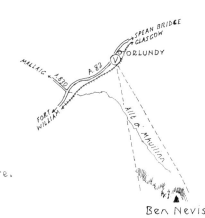

Ben Nevis

152 **Ben Nevis,** from Torlundy

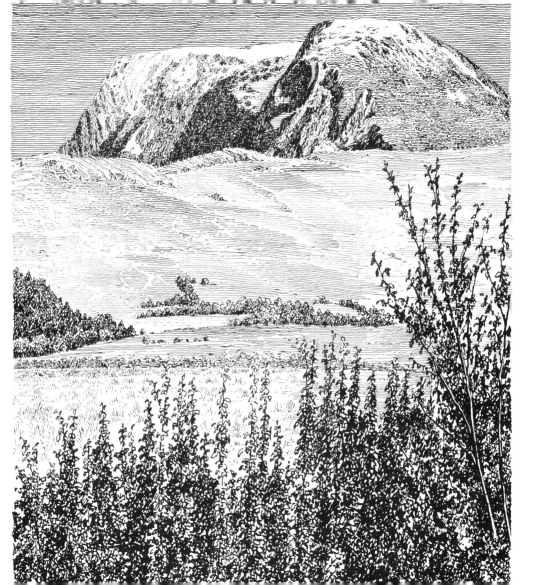

Glen Nevis provides intimate views of the massive
lower buttresses of Ben Nevis but the higher reaches
and the summit remain stubbornly unseen from the
usual tourist haunts. (The common question of visitors
at the terminus car park is "Where is Ben Nevis?").
But when the usual limits of tourist penetration are
passed and the open expanses of the upper valley
reached, the summit soars grotesquely into sight.

153 Ben Nevis, from upper Glen Nevis

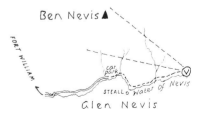

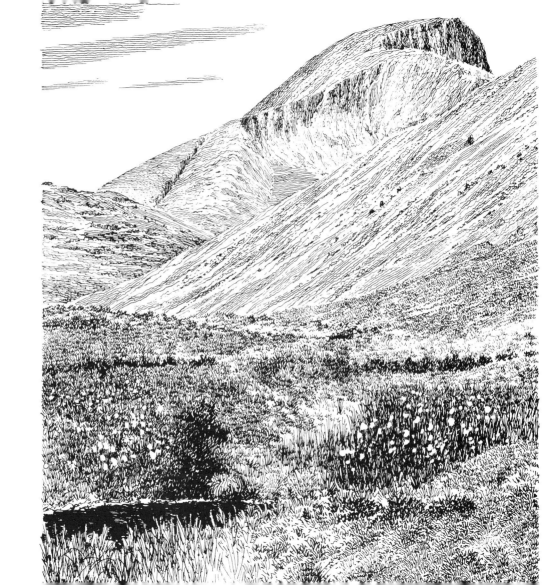

Cliffs 2000 feet high and unbroken for a mile in length jolt the senses of all who enter the upper sanctuary of the Allt a' Mhuilinn. Rock scenery so primeval, so spectacular, and on so gigantic a scale makes the north-east corrie of Ben Nevis a climbing ground and a showplace par excellence. The crags are palpably for experts only, but the thin track along the valley floor is open to all, and, followed to the ridge at its head, there turning right, is incomparably the finest pedestrian route to the summit of Ben Nevis.

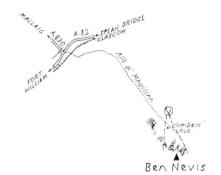

154 The cliffs of Ben Nevis

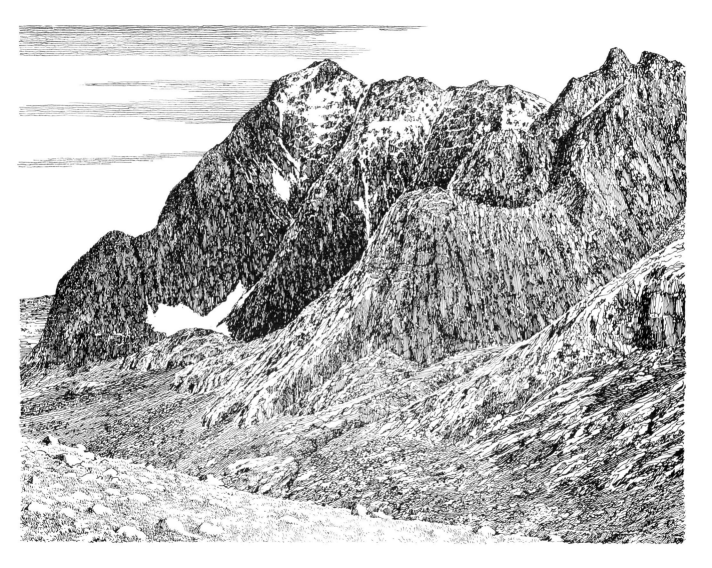

The pony track to the top of Ben Nevis from Achintee
climbs in a series of zig-zags to the summit plateau
and then takes a more exciting course skirting
the rim of the cliffs before reaching the ruins
of an observatory founded in 1883 and closed in
1904. With an average recorded rainfall of 157
inches annually, and shrouded in mist five
days out of seven, fortunate are they who
enjoy sunshine and clear visibility on their visit,
the view extending over half of Scotland to the Western Isles.

155 The summit of Ben Nevis

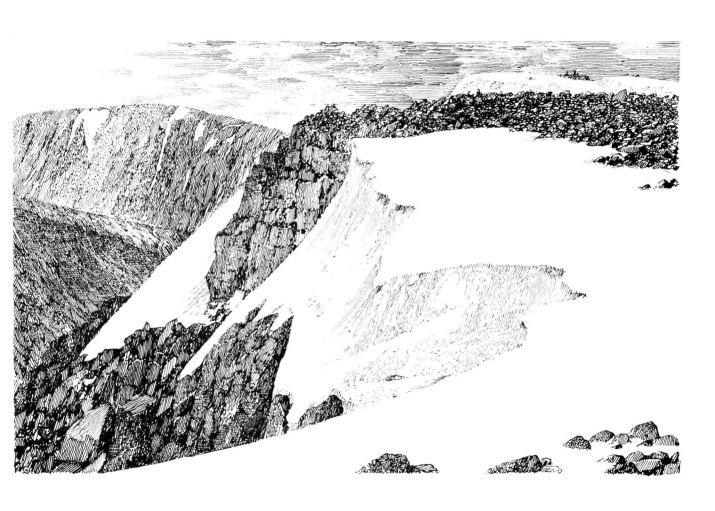

Càrn Mòr Dearg exceeds 4000 feet in height and is therefore a giant among mountains but so severely does it suffer from the powerful personality and proximity of Ben Nevis that it appears stunted and of little significance. It takes the fo m of a ridge rising in waves and then declining in a graceful arête, and is most often ascended not for any intrinsic merit but because it provides a superbly detailed and classic panorama of the cliffs of Ben Nevis.

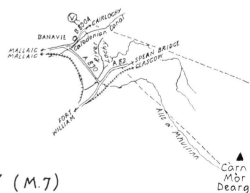

156 Càrn Mòr Dearg, 4012' (M.7)
(big red cairn)

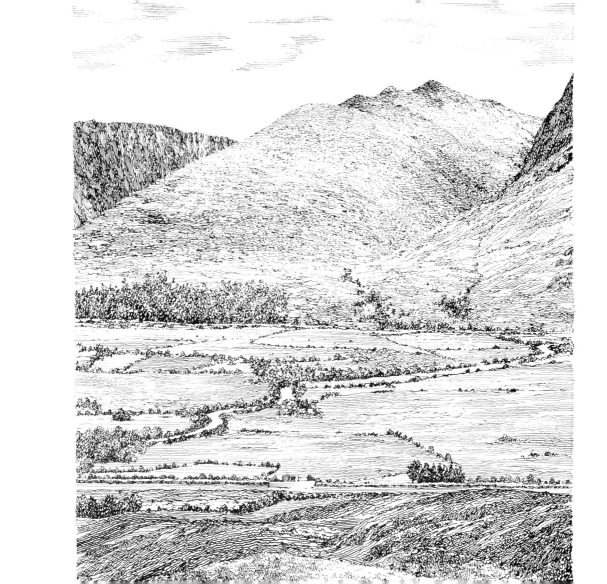

Aonach Mòr impinges more upon the eyes of travellers along the busy A.82 road at its base than does Ben Nevis itself. This is a huge sprawling mountain with a pronounced subsidiary shoulder forming a parapet on the east side and an abrupt termination in a conspicuous sharp peak above the valley, where the encroaching plantations of Leanachan Forest make a mile-wide barrier to direct access. Seen from the valley Aonach Mòr gives an impression of vastness and isolation but in fact the extensive top is linked at a high level with a noble twin — the less obtrusive Aonach Beag.

INVERNESS A 82 SPEAN BRIDGE A 86 ROY BRIDGE GLEN ROY A 86 AVIEMORE GLASGOW
FORT WILLIAM A 82 KILLIECHONATE COIRE CHAILLE River Spean Glen Spean
Leanachan Forest
Allt an Loin
The Cour
Sgùrr Finnisg-aig △
Aonach △ an Nid
▲ Aonach Mòr

157 Aonach Mòr, 3999'
(great ridge) (M.8)

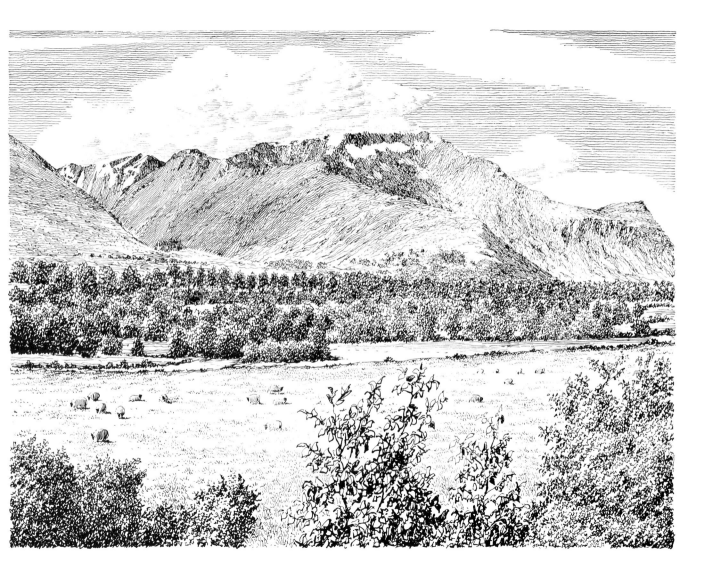

Although "Mòr" means big and "Beag" means little,
Aonach Beag is loftier than its close neighbour
Aonach Mòr, the distinction obviously being
determined by bulk rather than altitude. Aonach Beag
is the smaller in extent and moulded on slenderer lines
with an exciting skyline hidden by its big brother
from the sight of tourists on wheels but starkly
revealed to walkers near the Glen Nevis watershed.

▲ Aonach Beag

GLEN
NEVIS
Water of Nevis

Amhainn Rath
CORROUR

158 Aonach Beag, 4060′ (M.6)
(little ridge)

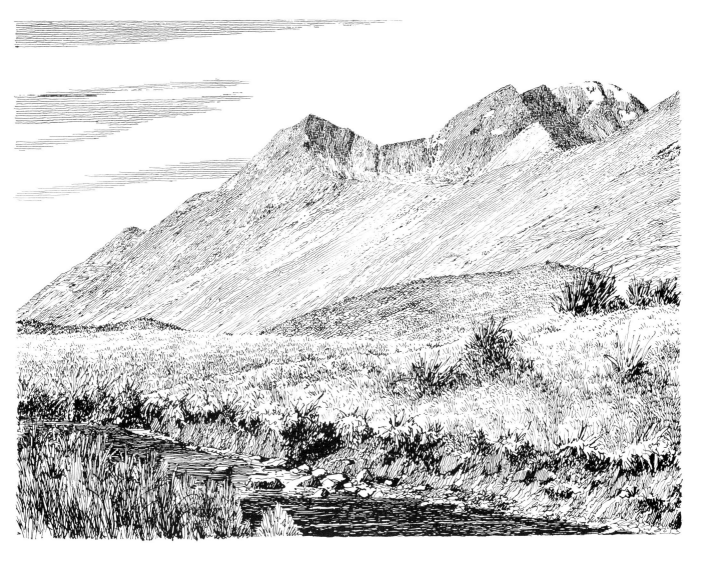

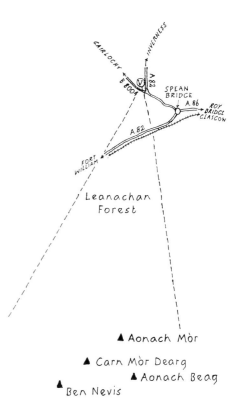

The Commando Memorial, on a hill alongside the A82 above Spean Bridge, was erected in 1952 in recognition of the services of the Commandos, for whom the region was a training ground during the 1939-1945 war. The site is most magnificent, giving an uninterrupted prospect of the whole of the Ben Nevis range including the Grey Corries: a mountain array without parallel on the mainland. The Memorial is a compulsive stop for passers-by.

159 The Ben Nevis range

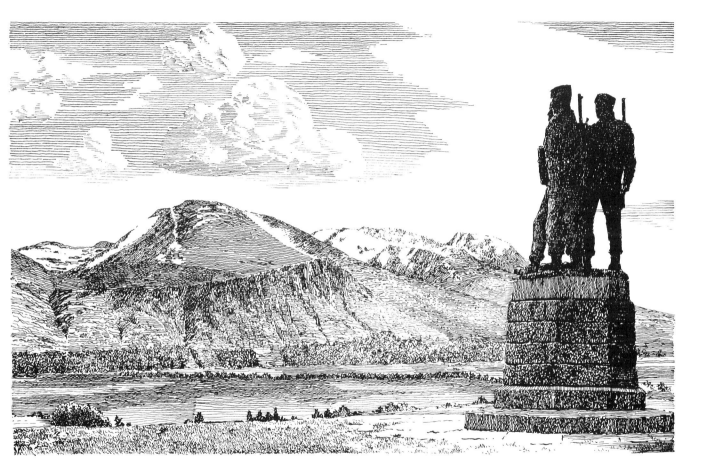

The two Sgùrr Chòinnichs link the Aonachs with the
Grey Corries. They are well seen from the Glen Nevis
watershed, to which, however, they display featureless
slopes that belie their true character, the summit-ridge
and northern declivities being much grander.

160 Sgùrr Chòinnich Beag, 3175′
 and (little mossy peak)
 Sgùrr Chòinnich Mòr, 3603′ (M.48)
 (big mossy peak)

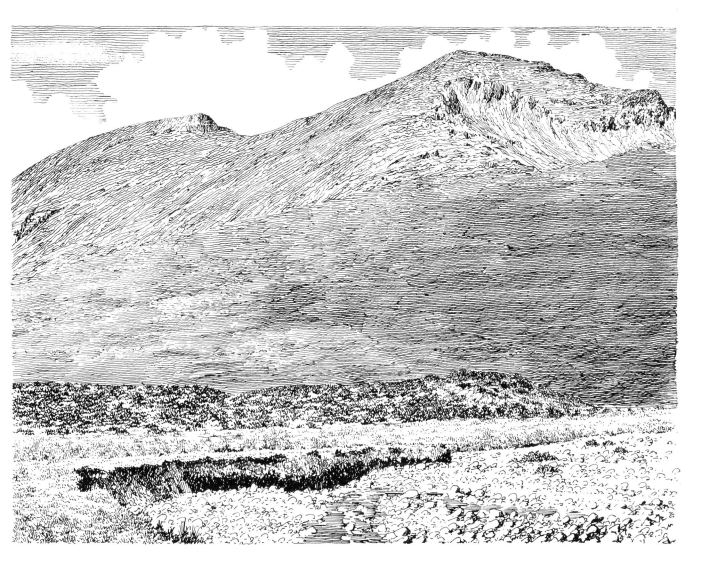

Not unlike the better-known Beinn Eighe in Torridon the higher parts of the Grey Corries are draped with pale screes that, in sunlight, may be mistaken for snow. Stob Coire an Laoigh, concealed in views from the north but in full view to the south, is the highest point on an elevated ridge with many 'tops' that culminates in the loftiest of the group, Stob Choire Claurigh.

161 Stob Coire an Laoigh, 3659' (M.34)
(peak of the corrie of the calf)

▲ Stob Coire
an Laoigh

GLEN
NEVIS

Amhainn Rath
CORROUR

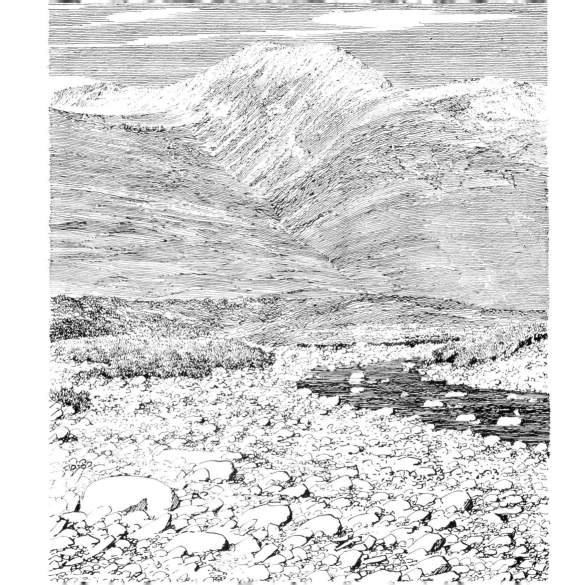

Caisteal is named only on the 6" Ordnance Survey maps.
It is the central top on the undulating main ridge of the
Grey Corries but, despite its considerable height, is not
classed as a Munro, this distinction being given to the
two terminal summits on the ridge.
The usual approach to the ridge is along the valley of
the Cour, which, although severely encroached upon by
recent afforestation, retains its natural river-fringe of
trees and gives a pleasant route, facilitated by new
forest roads, from Glen Spean.

162 Caisteal, 3609'
(the castle)

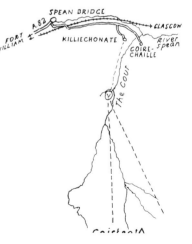

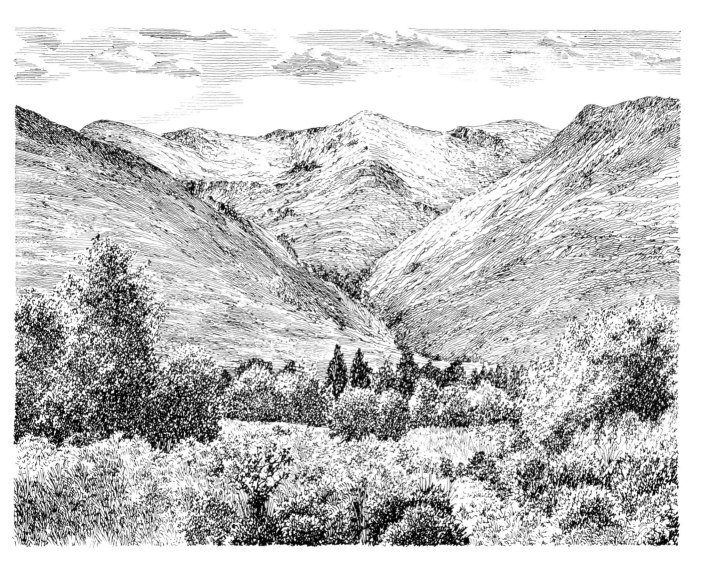

Stob Choire Claurigh is the undisputed king of the Grey Corries, overtopping all other peaks in the group and exerting its dominance in every view in which it is seen. It is a splendid mountain, with a finely-carved summit rising above massive buttresses and identifiable with certainty by the shapely pyramid of a subsidiary top, Stob Coire na Ceannain.

163 Stob Choire Claurigh, 3858' (M.14)

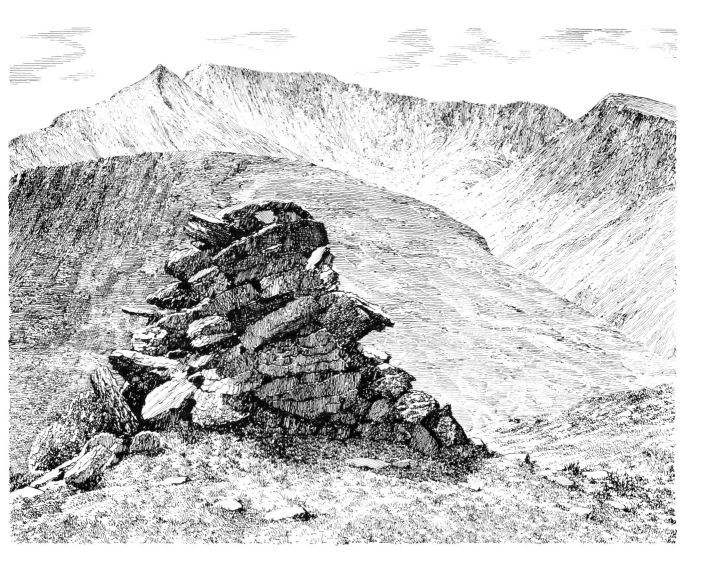

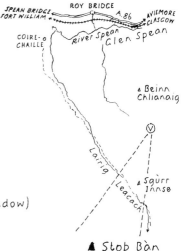

Stob Bàn is the shyest of the Grey Corries group, being concealed from most viewpoints by the tremendous bulk of Stob Choire Claurigh. Oddly, though, it is the peak that most catches the eyes of travellers proceeding west on the A.86 near Loch Moy, appearing in the midst of higher mountains as a perfect pyramid.
 Sgùrr Innse is lower but strongly individual, attracting attention by an abrupt and aggressive outline.

164 Sgùrr Innse, 2600' (peak of the meadow)
Stob Bàn, 3217' (M.162)
(white peak)

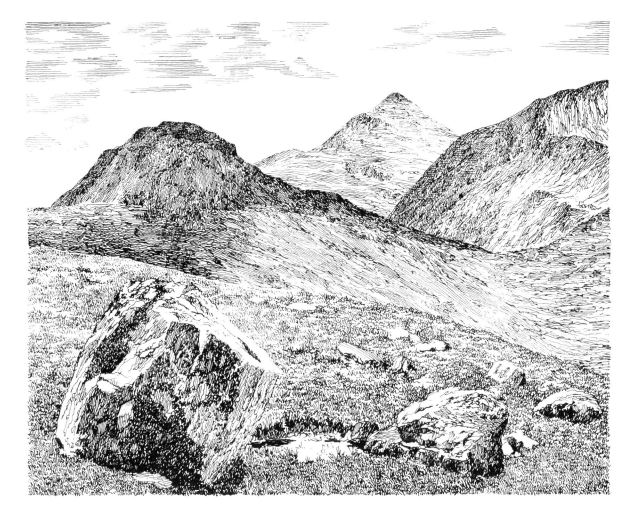

The Ben Nevis range terminates abruptly in the east with two major mountains, Stob a' Choire Mheadhoin and Stob Coire Easain, the domed summit of the former being closely linked to the sharp peak of the latter. Stob Coire Easain is the more imposing, being distinguished by a fluted cliff below the steep upthrust of the summit. Both are impressively seen from the railway alongside Loch Treig, to which they fall in a rough and unremitting declivity.

165 **Stob a' Choire Mheadhoin,**
(peak of the middle corrie) **3610' (M.47)**

Stob Coire Easain, 3658' (M.35)
(Stob Choire an Easain Mhoir)
(peak of the corrie of the waterfalls)

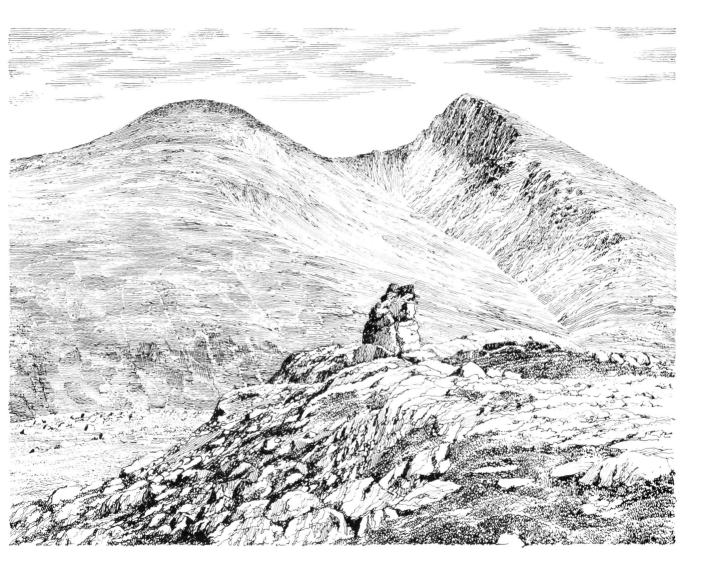

The Grey Corries are well seen from Glen Spean, their beautifully-carved skyline overtopping grassy foothills and the pallid colour of their summits having a spectral quality, especially in late evening sunlight, that adds a suggestion of unreality to the scene. In particular the lightly-etched cliffs and screes of Stob Choire Claurigh, delicately fluted, arrest and hold the attention until the shadows of night rob them of detail.

166 The Grey Corries

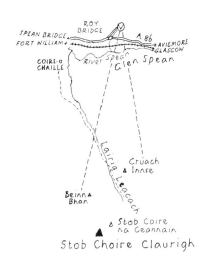

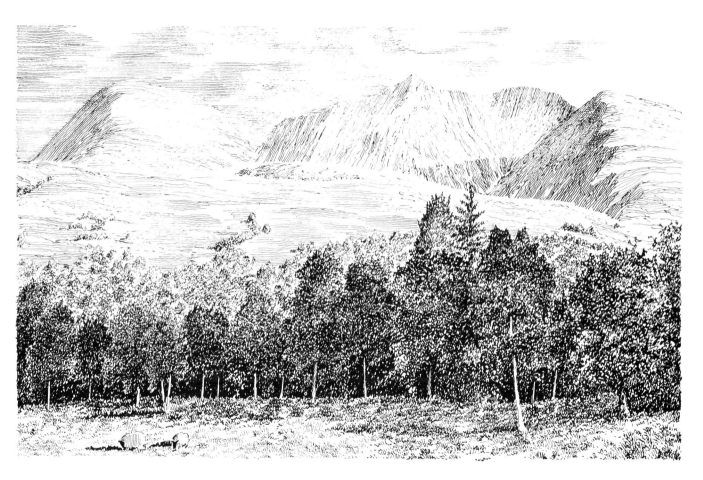

Glen Nevis is a remarkable valley, almost a ravine, penetrating so deeply into the heart of the mountains that, five miles in, its floor is no more than 100 feet above sea-level although crowded by rugged heights that soar above 3000. It is a beautiful valley, one of the loveliest in the Highlands, but its proximity to Fort William, caravan sites and a youth hostel, and an improved road that ends in a popular car park, all combine to attract visitors in increasing numbers. One has to be tolerant of crowds to enjoy Glen Nevis. Or go on through its spectacular Alpine gorge to reach the quiet open sheep pastures of the upper valley.

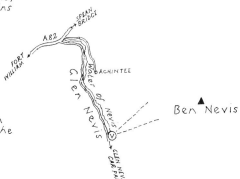

167 Glen Nevis

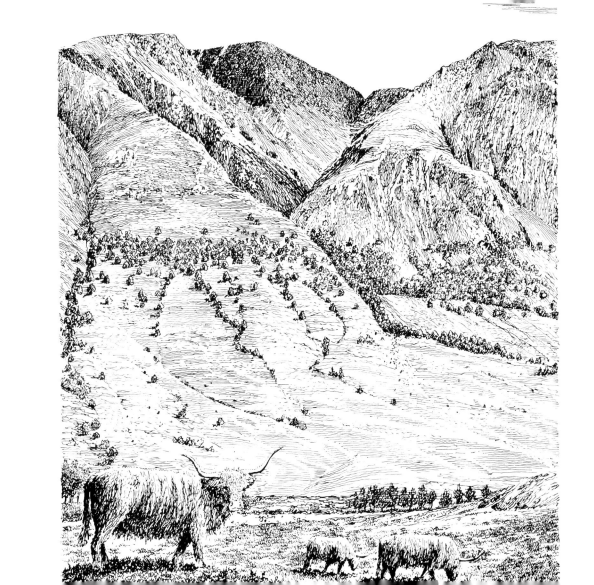

MAMORE FOREST

(DRAWINGS 168 to 181)

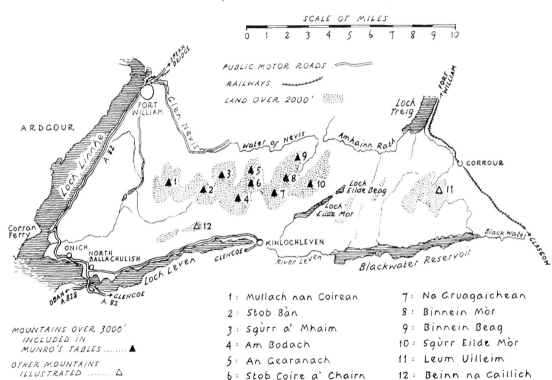

SCALE OF MILES

0 1 2 3 4 5 6 7 8 9 10

PUBLIC MOTOR ROADS
RAILWAYS
LAND OVER 2000'

ARDGOUR

FORT WILLIAM

SPEAN BRIDGE

Glen Nevis

Loch Linnhe

A.82

Corran Ferry

ONICH

NORTH BALLACHULISH

OBAN A.828

GLENCOE

A.82

Loch Leven

GLENCOE

KINLOCHLEVEN

River Leven

Water of Nevis

Amhainn Rath

Loch Treig

FORT WILLIAM

CORROUR

Loch Eilde Beag

Loch Eilde Mor

Blackwater Reservoir

Black Water

GLASGOW

1 2 3 4 5 6 7 8 9 10 11 12

MOUNTAINS OVER 3000'
INCLUDED IN
MUNRO'S TABLES ▲

OTHER MOUNTAINS
ILLUSTRATED △

1 : Mullach nan Coirean	7 : Na Gruagaichean
2 : Stob Bàn	8 : Binnein Mòr
3 : Sgùrr a' Mhaim	9 : Binnein Beag
4 : Am Bodach	10 : Sgùrr Eilde Mòr
5 : An Gearanach	11 : Leum Uilleim
6 : Stob Coire a' Chairn	12 : Beinn na Caillich

The mountains of Mamore Forest, affectionately known as the Mamores, form a compact mass quite independent of other groups, being extremely well defined by boundaries that give no cause for doubt. In the north the gulf of Glen Nevis very effectively severs the Mamores from the Ben Nevis range, there being no connecting links of high ground; westwards is Loch Linnhe, and in the south Loch Leven. Only towards the east does undulating terrain persist, with a few minor summits and ridges of relative insignificance, but even in this direction there is a clear distinction between the mountains and the foothills.

The Mamores are a magnificent group. They do not attain the elevation of the Ben Nevis range but are fully compensated by clearer-cut outlines, sharp summits, and, although closely crowded together, by the remarkably strong individuality of each member. For the Munro enthusiast this is a paradise: there are ten mountains of Munro status within a distance of a few miles, separated by profound corries yet linked one to another by airy ridges. In general the summits are abruptly peaked or steeply domed, the ridges rocky and narrow. This is an area par excellence for experienced ridge-walkers, with interest and excitement all the way from one splendid summit to the next. Super-walkers can visit all the tops in a long day's expedition; lesser mortals could spend a rewarding week on the pleasurable task.

The western mountains in the group are most conveniently climbed from Glen Nevis, using Fort William as a base; those to the east have their best routes of ascent from the small town of Kinlochleven, to which some writers have been less than kind, dismissing it summarily as an urban sprawl centred on a large aluminium works. In fact the situation of the town in relation to the Mamores could not be bettered, and the surroundings abound in lovely walks in a setting of river and loch and woodland. Kinlochleven, recognising its deficiencies as a holiday resort, does not cater much for visitors, but there are caravan sites and camping in the vicinity. Nights under a tin or canvas roof are tolerable when the days hold so much promise of exhilarating mountain adventures and yield so great a reward. Walks on the Mamores are walks long remembered:

Mullach nan Coirean is the most westerly
of the Mamores, and the nearest to Fort William.
The afforested lower slopes edge the road in
Glen Nevis, the higher parts of the mountain
being hidden by them until revealed from the
terminus of the road. It is more in evidence
from the old military road (Fort William —
Kinlochleven) skirting its southern base.
Unlike the other mountains of Mamore Forest,
the bedrock of the Mullach is granite.

168 Mullach nan Coirean, 3077' (M.228)
(top of the corries)

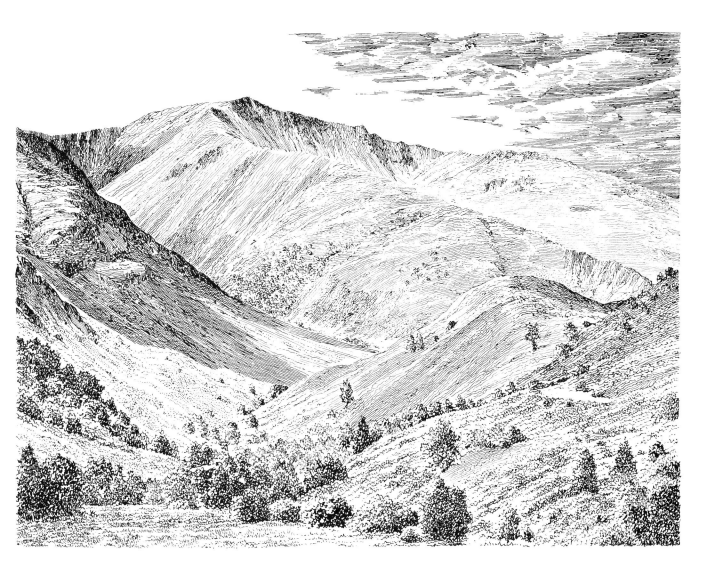

Stob Bàn, prominently in view on the approach
along the road in Glen Nevis, rises immediately
from the valley at Achriabhach. The ascending ridge,
which becomes and continues precipitous on the
eastern side, culminates in a splendid peak of
quartzite, the screes of which give an ashen
pallor to the upper slopes.

169 Stob Bàn, 3274' (M.135)
(white peak)

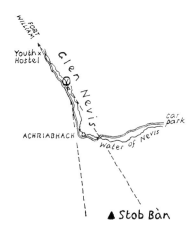

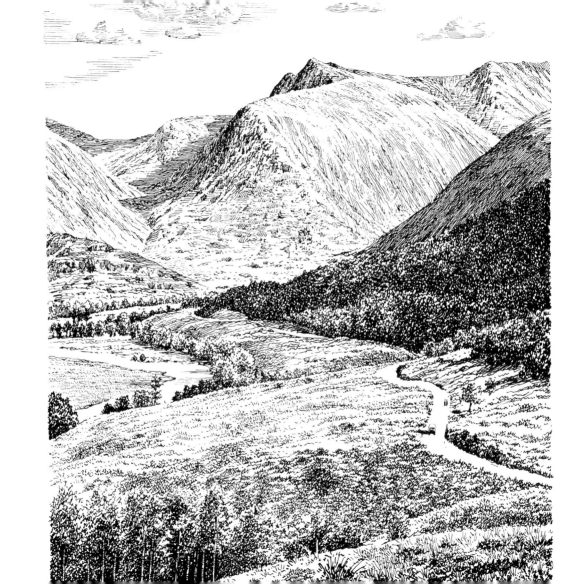

Second highest of the Mamores, Sgùrr a' Mhaim
is the most prominent object throughout the length
of Glen Nevis and from all viewpoints is magnificent,
its quartzite cap and delicately carved corrie
under the summit being distinctive features.

170 Sgùrr a' Mhaim, 3601' (M.50)
(peak of the pass)

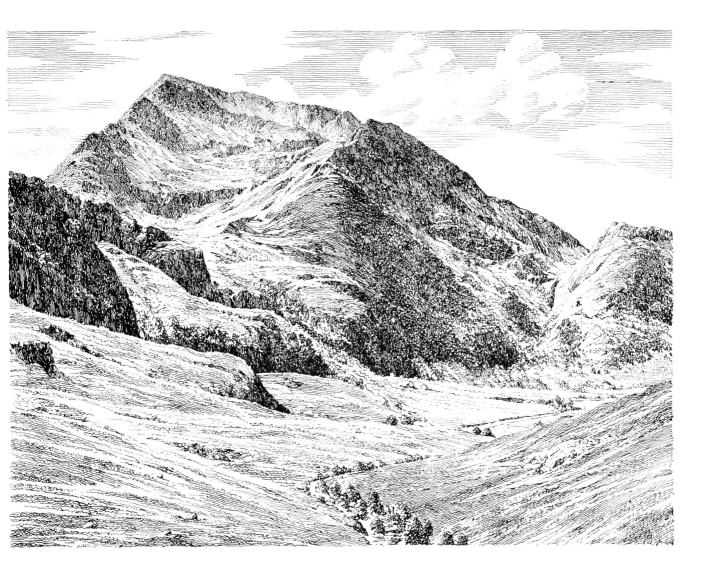

Am Bodach, unseen from Glen Nevis, is conspicuous
southwards above Kinlochleven, rising therefrom
in a broad-based buttress, wooded in its lower parts
around the buildings of Mamore Lodge but becoming
narrower and rockier and finally tapering to a ridge
leading up to a final pyramid.

171 Am Bodach, 3382' (M.96)
(the old man)

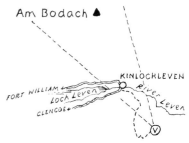

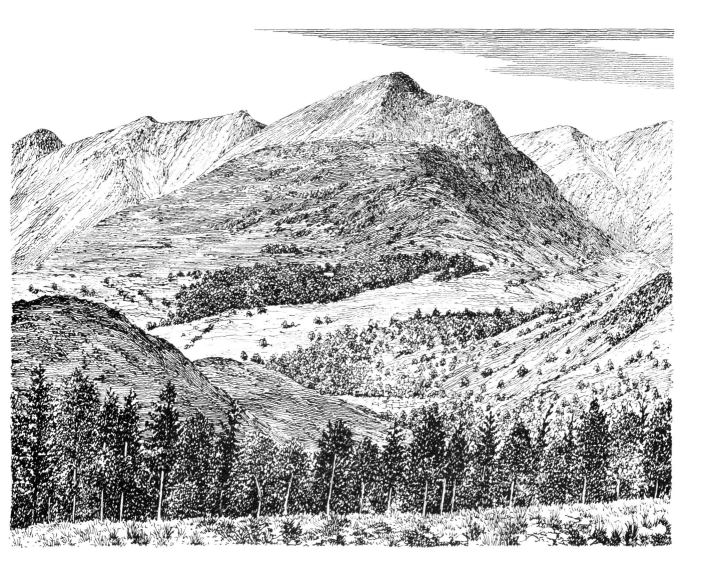

Most visitors to the car-park at the end of the road in Glen Nevis are aware that there is a waterfall to be seen hereabouts; many wrongly assume it to be the long cascade that comes down to the car-park, and go no further. Steall Waterfall, however, is a rough mile onwards, through a spectacular wooded gorge, when the fall comes suddenly into view across a flat 'meadow'.

172 Steall Waterfall

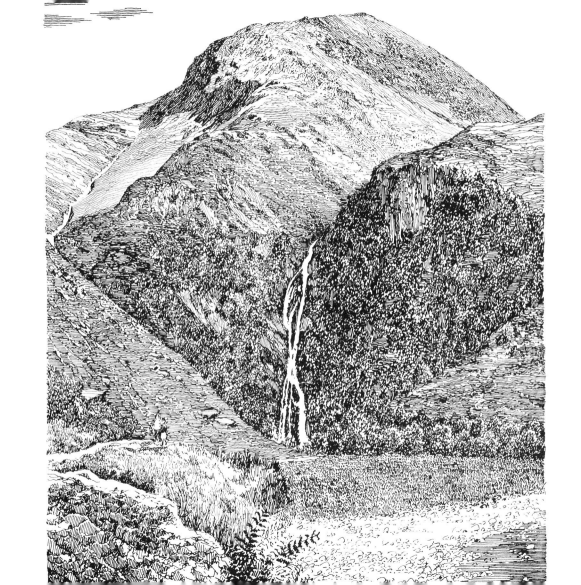

An Gearanach does not come fully into view until the
Glen Nevis path (to Corrour) from the isolated cottage
of Steall (a climbing hut) is followed for two miles,
when it is splendidly displayed as a peaked top
on a high ridge with a companion of equal height,
An Garbhanach, to the south. This ridge is not
seen at all from the Loch Leven area. On
1" Ordnance maps An Gearanach is not named.

FORT WILLIAM

Glen
Nevis

car
park

ACHRIABHACH

Water of Nevis

STEALL

Allt Coire a'Mhail

▲ An Gearanach

173 An Gearanach, 3200' (M.172)
(the short ridge)

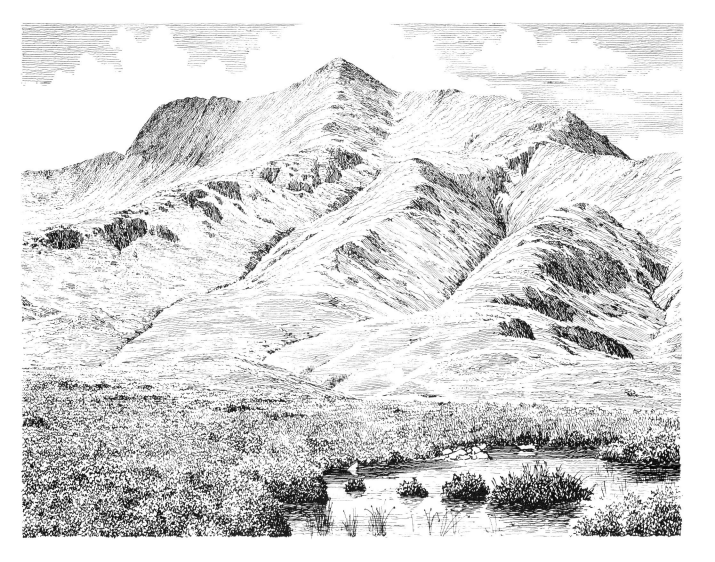

Stob Coire a' Chairn, not named on 1" Ordnance maps,
is a peak at a junction of ridges and overlooks the
profound hollow of the Allt Coire na Bà. With high links
in three directions to other mountains of the group
Stob Coire a' Chairn occupies a position of strategic
importance in the pattern of the Mamores.

Stob Coire a' Chairn

FORT WILLIAM
Loch Leven
GLENCOE
KINLOCHLEVEN

174 Stob Coire a' Chairn, 3219' (M.159)
(peak of the stony corrie)

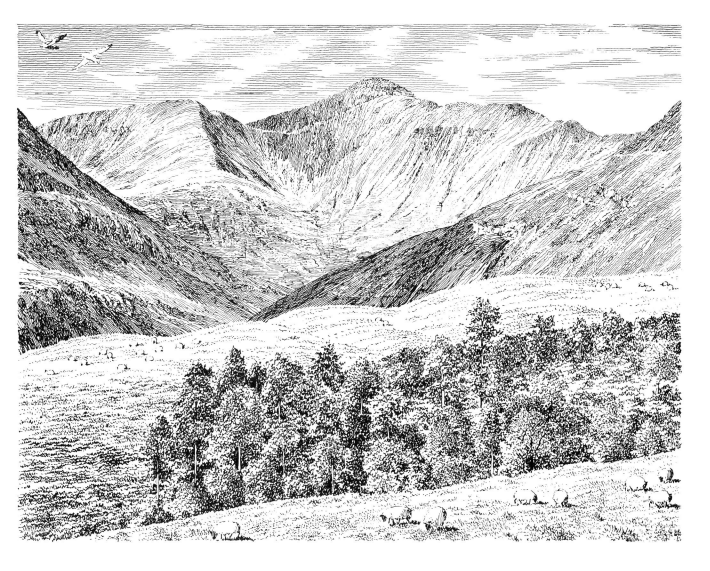

Na Gruagaichean, fully in view on the approach to Kinlochleven along the road from Glencoe, has two tops of similar elevation above an impressive bulk. It is the highest mountain in the scene, hiding, from this direction, the giant of the Mamores, Binnein Mor, a mile beyond it.

Na Gruagaichean

FORT WILLIAM
Loch Leven
GLENCOE
KINLOCHLEVEN

175 Na Gruagaichean, 3442' (M.77)
(A' Gruagach) (the maidens)

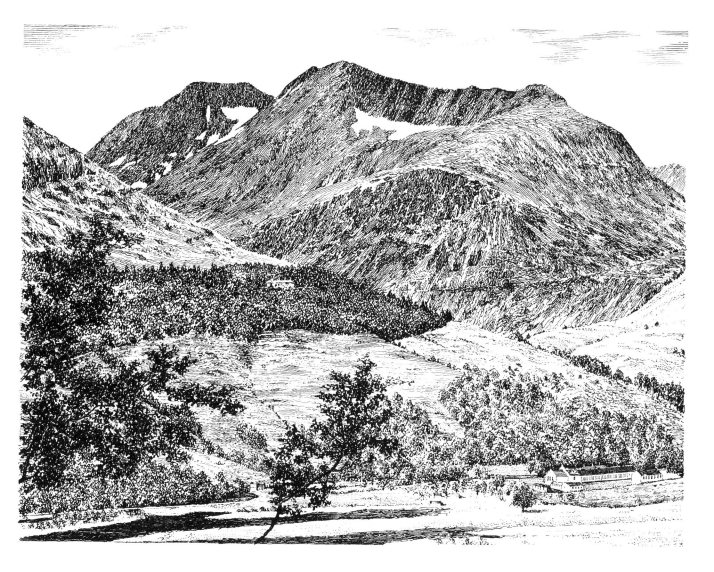

The full stature of Binnein Mòr, the loftiest of the Mamores, is excellently displayed to the upper reaches of Glen Nevis, rising to a fine peak above steepening slopes, although in fact the summit takes the form of a ridge declining to the south; it is liberally furnished with quartzite screes. The ascent is more usually made from Kinlochleven, taking advantage of a path that leads to within a mile of the top.

176 Binnein Mòr, 3700' (M.27)
(big hill)

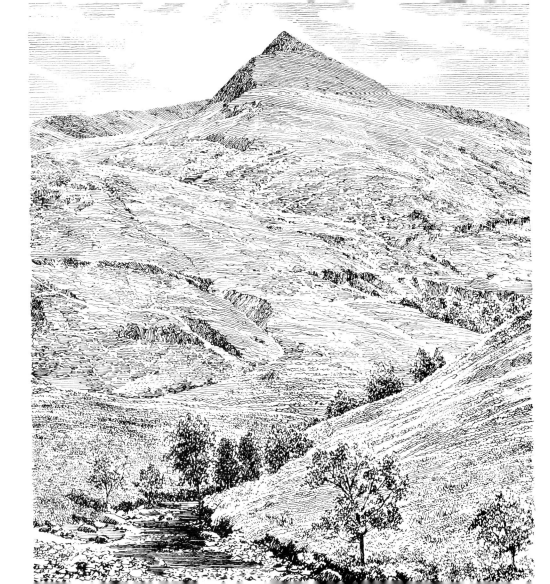

Binnein Beag is essentially a mountain within
the domain of Glen Nevis, being seen intimately
only from that valley, to which it appears
as a simple and symmetrical domed
pyramid of quartzite screes.

FORT WILLIAM ← car park · Glen Nevis · CORROUR
STEALL · Water of Nevis · ▲ Binnein Beag

177 Binnein Beag, 3083' (M.227)
(little hill)

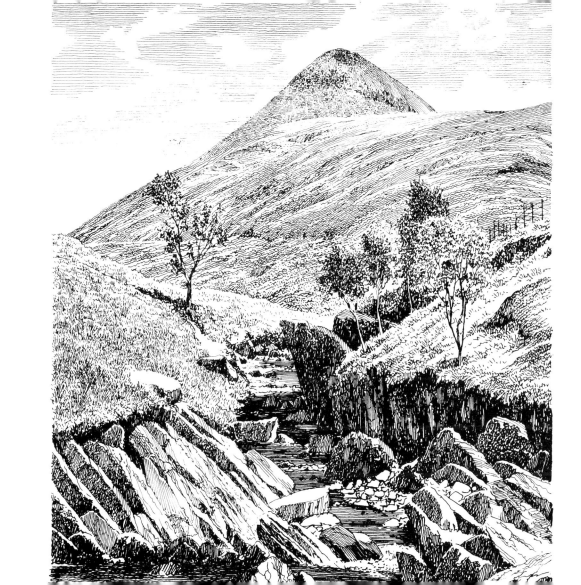

Sgùrr Eilde Mòr, the most easterly and the shyest of the Mamore Munros, comes into view as a shapely peak on the climb from Kinlochleven to Loch Eilde Mòr, being better seen from the pathless south shore of the loch. Other aspects are disappointing, the mountain rising from the north in dull slopes unworthy of the proud company of which it is a member.

178 **Sgùrr Eilde Mòr, 3279'**
(Sgùrr na h-Eilde) (M.132)
 (big crag of the hinds)

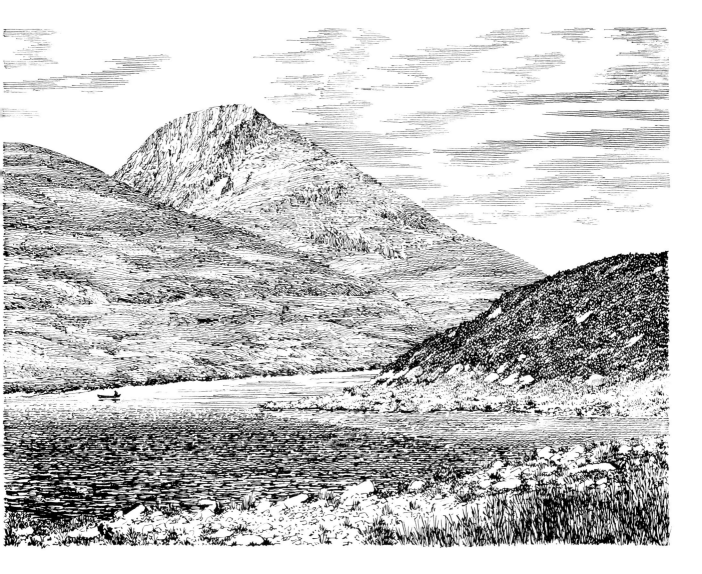

The name is a change from the usual Stobs and Squrrs and Beinns and its interpretation suggests a forgotten story that must have been worth telling. Leum Uilleim is a far outpost of Mamore Forest. It stands with a lesser neighbour in isolation overlooking the Moor of Rannoch and the West Highland Railway. The lonely Corrour Station is in its evening shadow.

179 Leum Uilleim, 2971'
 (William's leap)

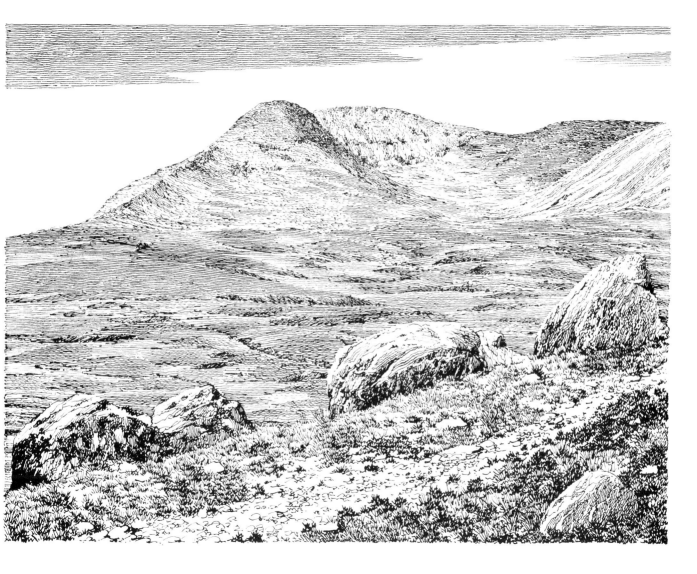

Beinn na Caillich is a minor mountain of Mamore Forest but has nevertheless a commanding presence alongside Loch Leven and is a familiar object on the drive to Kinlochleven.

180 Beinn na Caillich, 2502'

Beinn na Caillich △

KINLOCHLEVEN

FORT WILLIAM

LOCH Leven

GLENCOE

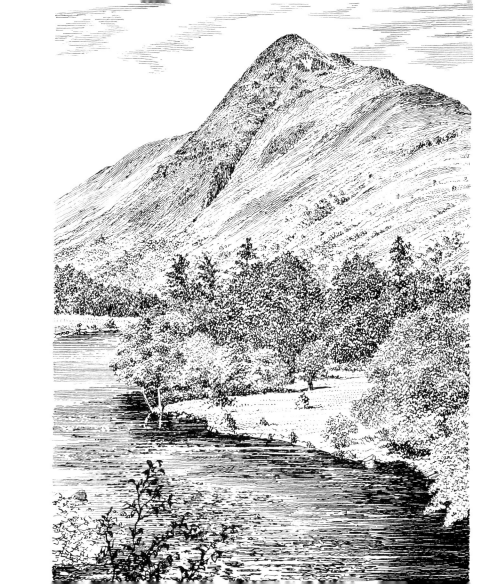

Many of the western sea-lochs penetrate deeply into the mountains of the interior, forming narrow and sinuous channels that add greatly to the scenic charm of the coastal area. Amongst these is Loch Leven, seen to perfection from the low hills behind Kinlochleven.

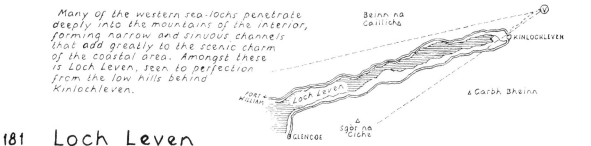

181 Loch Leven

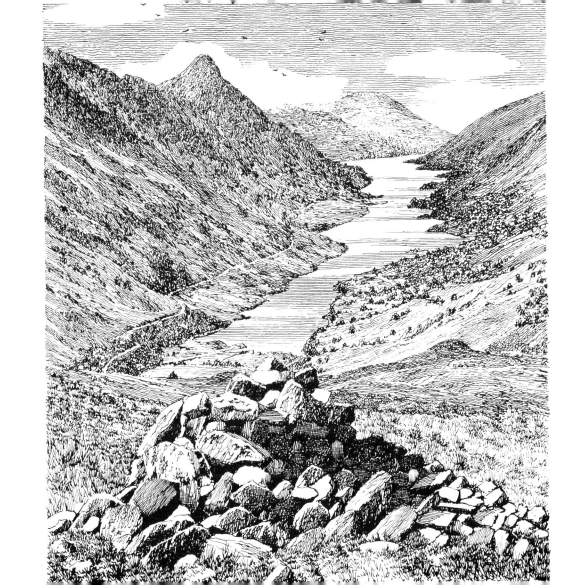

GLEN COE

(DRAWINGS 182 to 193)

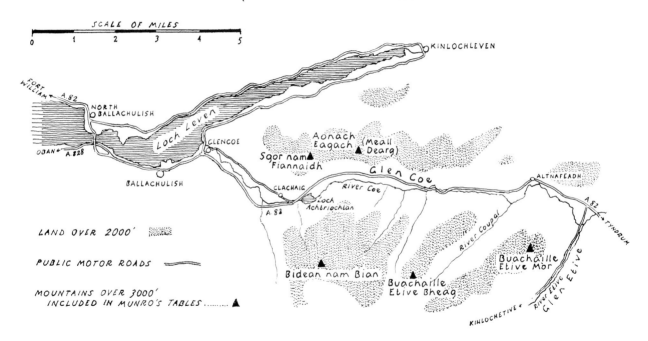

SCALE OF MILES

0 1 2 3 4 5

FORT WILLIAM

A.82

NORTH BALLACHULISH

OBAN A.828

Loch Leven

KINLOCHLEVEN

GLENCOE

BALLACHULISH

CLACHAIG

A.82

Loch Achtriochtan

River Coe

Glen Coe

ALTNAFEADH

A.82 TYNDRUM

Sgor nam Fiannaidh

Aonach Eagach (Meall Dearg)

River Coupal

Bidean nam Bian

Buachaille Etive Bheag

Buachaille Etive Mòr

River Etive

Glen Etive

KINLOCHETIVE

LAND OVER 2000′

PUBLIC MOTOR ROADS

MOUNTAINS OVER 3000′
INCLUDED IN MUNRO'S TABLES ▲

The two places in Scotland probably most universally known by name outside the country are Loch Lomond and Glen Coe, the first for its romantic ballads, the other for a grim incident in history. Loch Ness, with its monster, is, as yet, a poor third.

Nearly 300 years after the event the Massacre of Glen Coe is still a subject of discussion and thesis. There have been worse massacres, bigger acts of genocide, but never has there been a greater stratagem of treachery and slaughter, nor a betrayal more alien to the true character of the Highlanders than the happenings in Glen Coe in February 1692.

The scene of the crime could not be more fitting. Glen Coe is a savage glacial defile threatened by impending cliffs: the most impressive, awesome and forbidding glen in Scotland. There is desolation, there is fear, there is nothing of loveliness in its gloomy depths. Not even the road along it, thronged by the cars of tourists in the height of summer, relieves the loneliness of the barren landscape. Only in evening sunlight does the harshness relent and give way to a strange fleeting beauty.

The glen is flanked on both sides by mountains of intimidating steepness and unique individuality. On the north is the Aonach Eagach ridge, a jagged skyline above a wild tumble of crag and scree that bears traces of many landslips. On the south side is an imposing array of rock buttresses deeply severed by watercourses descending from hidden corries high above, and there are glimpses of peaks higher still: all this mass, a complicated labyrinth of ridges and corries and ravines, a tangled landscape, goes under the general name of Bidean nam Bian: the grandest mountain in Argyll. Yet Bidean is unusual in concealing its uppermost summit from popular gaze, the top being withdrawn behind two prominent satellites, Stob Coire nam Beith and Stob Coire nan Lochan, both of which are glimpsed from the road in Glen Coe and too often wrongly accredited with its name. Only from neighbouring elevations or the distant shores of Loch Leven and Loch Linnhe is the summit of Bidean nam Bian shyly revealed and the mountain's true proportions appreciated.

At the upper end of Glen Coe the road enters the lonely wastes of Rannoch Moor, passing the last outpost of the glen: the magnificent rock pyramid of the Buachaille Etive Mòr, the Great Shepherd of Etive, as bold as Bidean is retiring. There are a hundred mountains in Scotland of greater height but none more dominating, none more commanding attention and deserving it. In Glen Coe it has worthy company.

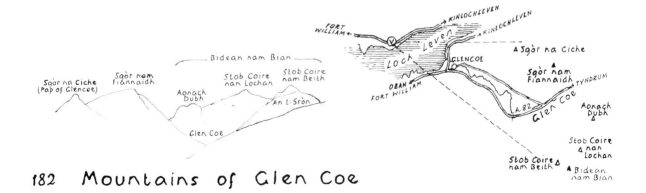

Bidean nam Bian

Sgòr na Ciche
(Pap of Glencoe)

Sgòr nam
Fiannaidh

Aonach
Dubh

Stob Coire
nan Lochan

Stob Coire
nam Beith

An t-Sròn

Glen Coe

FORT
WILLIAM

KINLOCHLEVEN

KINLOCHLEVEN

KINLOCHLEVEN

Loch Leven

GLENCOE

▲ Sgòr na Ciche

OBAN
FORT WILLIAM

A.82

Glen Coe

Sgòr nam
Fiannaidh ▲

TYNDRUM

Aonach
Dubh ▲

Stob Coire ▲
nam Beith

Stob Coire
▲ nan
Lochan

▲ Bidean
nam Bian

182 Mountains of Glen Coe

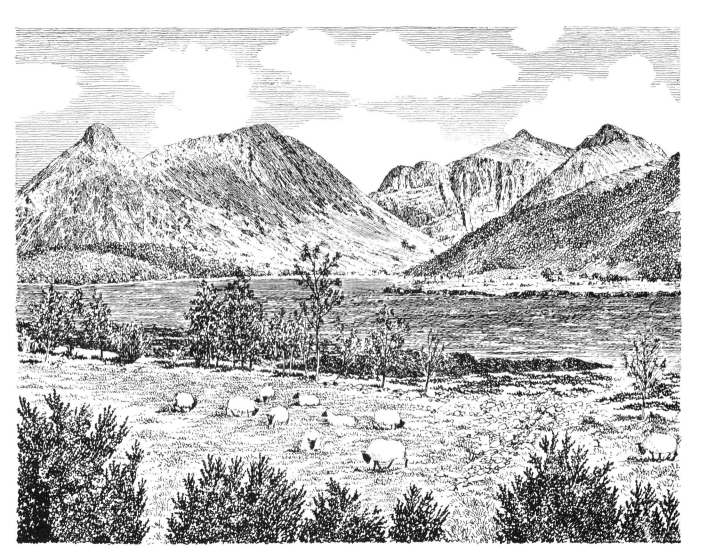

Sgòr nam Fiannaidh, forming the western end of the
Aonach Eagach ridge, is the least attractive of the
Glen Coe mountains but is notable for, and easily
identifiable by, a deep cleft in its southern flank.
The viewpoint is the Celtic cross near the village
of Glencoe commemorating MacIan, Chief of the
MacDonalds, who perished in the massacre of 1692.

183 Sgòr nam Fiannaidh, 3168' (M. 183)
(peak of the Fianns (Fingal's army))

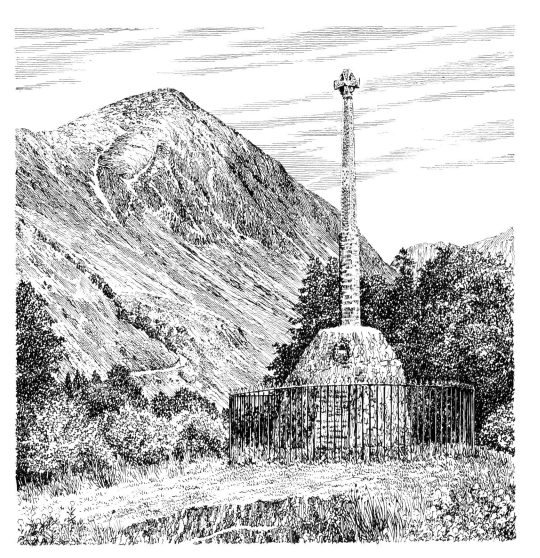

The Clachaig Gully is a long deep ravine in the side of Sgòr nam Fiannaidh directly above the Clachaig Inn, giving, for experts only, a severe and continuous rock climb of 1700 feet. ·The first ascent by W.H. Murray and three companions in 1938 is vividly described in his classic book 'Mountaineering in Scotland.'

184 The Clachaig Gully

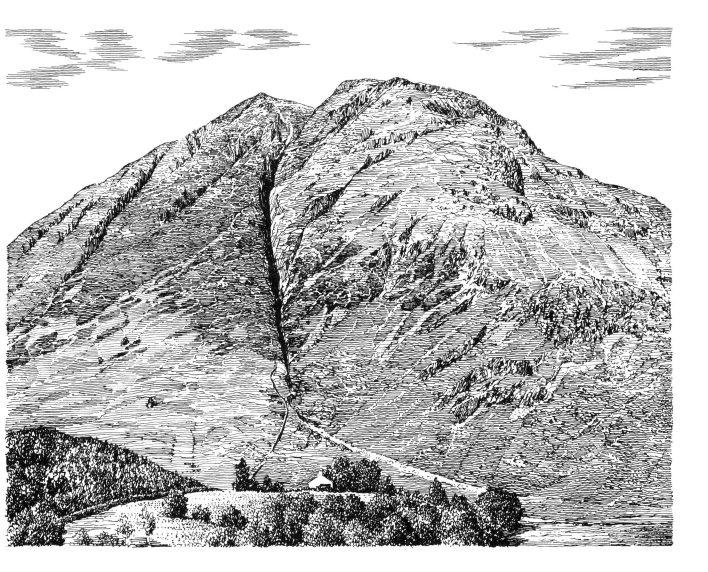

The pinnacled crest of Aonach Eagach, which forms an unbroken
and formidable north wall to Glen Coe, is a rival
to An Teallach as the narrowest and finest ridge on
the mainland. It is for competent mountaineers only.

185 Aonach Eagach
 (notched ridge)
 summit named **Meall Dearg, 3118' (M.207)**
 (red hill)

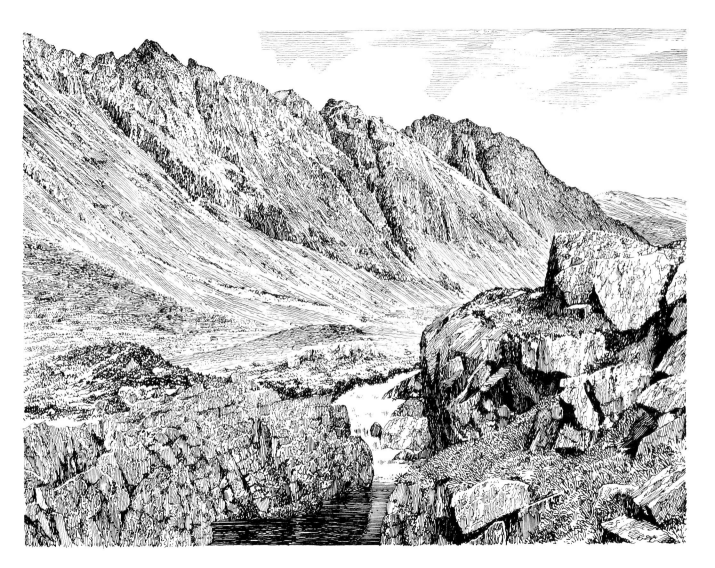

Am Bodach terminates the ridge of
Aonach Eagach in the east, where it
thrusts into Glen Coe in a towering
and apparently unassailable cliff.

Aonach Eagach △ Am Bodach

GLENCOE ←
VILLAGE River Coe A.82 ALTNAFEADH
 Glen Coe → TYNDRUM

186 Am Bodach, Aonach Eagach,
 (the old man) **3085'**

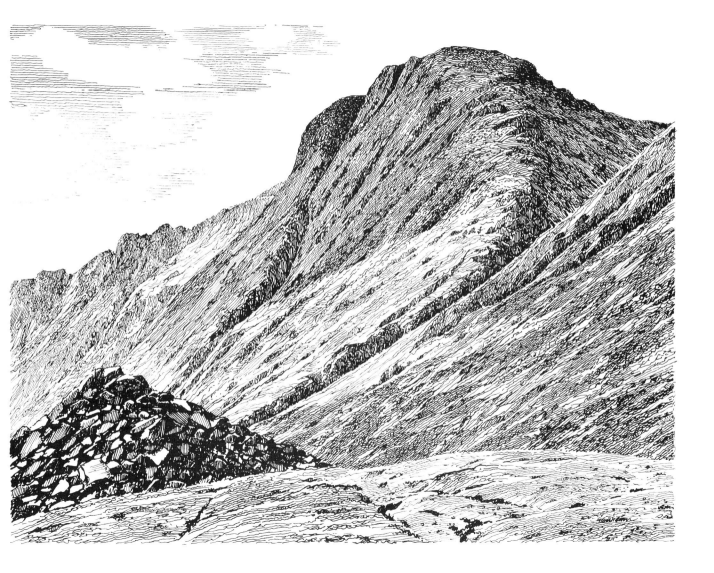

Of all Scottish mountains, probably
Buachaille Etive Mòr wins the most
admiration. Seen from the road at its base
its soaring pyramid of naked rock, split into
buttresses and towers, and tapering to a fine peak,
is beautifully proportioned. Here are some of the earliest
rock-climbs in the Highlands and they remain amongst
the best. The summit is named Stob Dearg (red peak).

187 Buachaille Etive Mòr,
(the great herdsman of Etive) 3345' (M. 106)

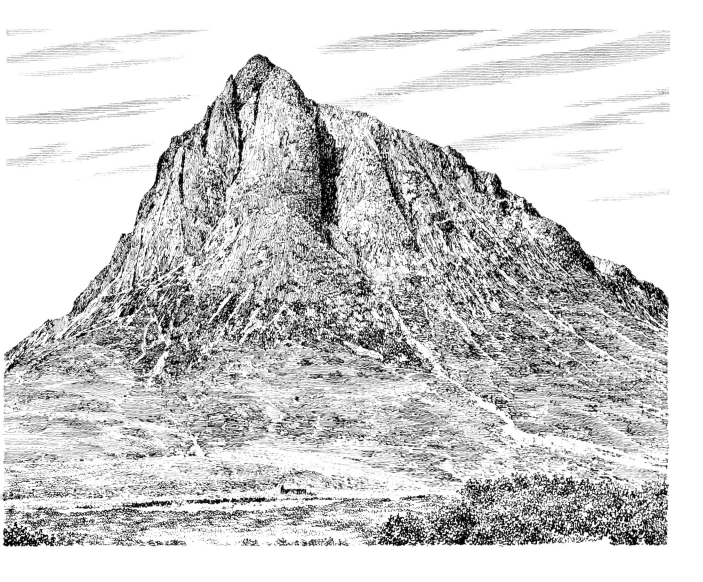

Fashioned on similar lines to Buachaille
Etive Mòr but lacking its bulk and formidable
appearance, Buachaille Etive Bheag rises alongside
its illustrious neighbour across the gulf of the
Lairig Gartain. Its summit is named Stob Dubh (black peak).

GLEN COE ←

A.82 ALTNAFEADH

→ TYNDRUM

▲
Buachaille Etive Bheag

188 Buachaille Etive Bheag,
(the little herdsman of Etive)
3130' (M.199)

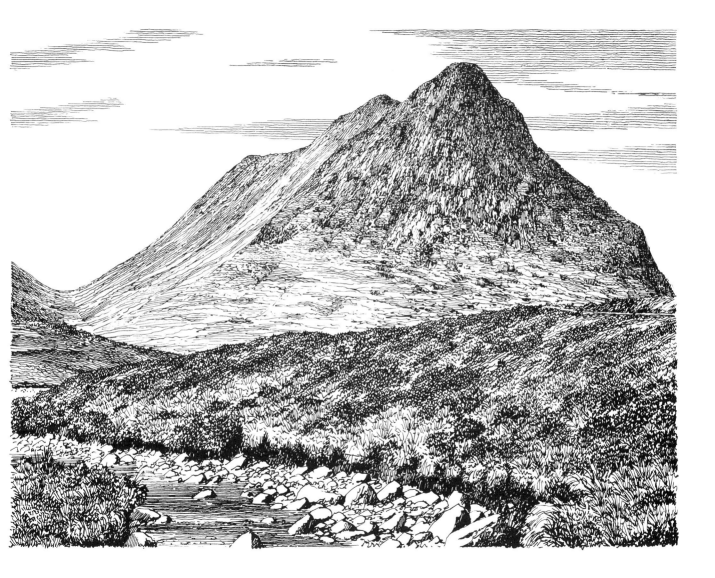

Not only to the north do the two Buachailles
dominate the scene; to Glen Etive, southwards,
they display a graceful symmetry of outline
that makes their kinship absolute, with twin
towers soaring high above the smooth curve
of the Lairig Gartain. It is significant that, although
the southern aspect of these mountains is today less
well known, they include 'Etive' in their names, suggesting
that it was to this direction they were originally
most familiar.

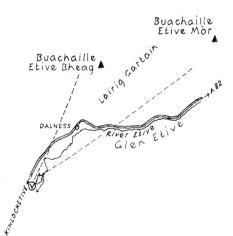

189 The Shepherds of Etive

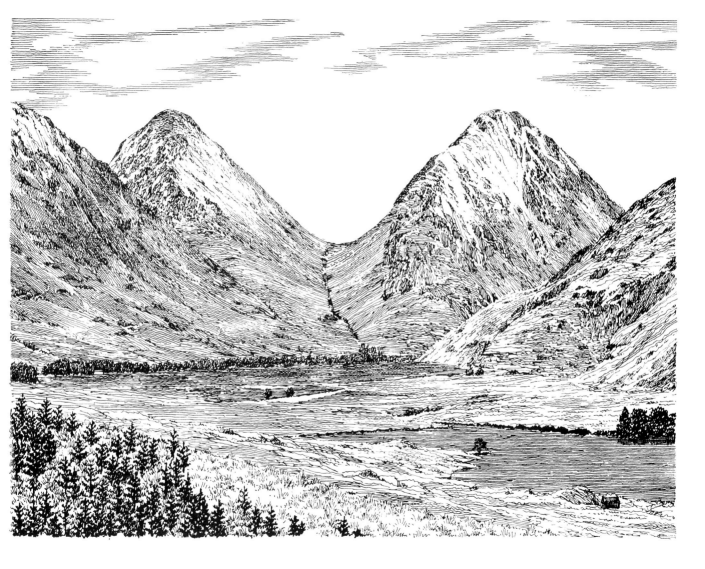

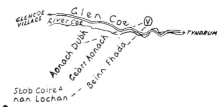

190 The Three Sisters of Glen Coe

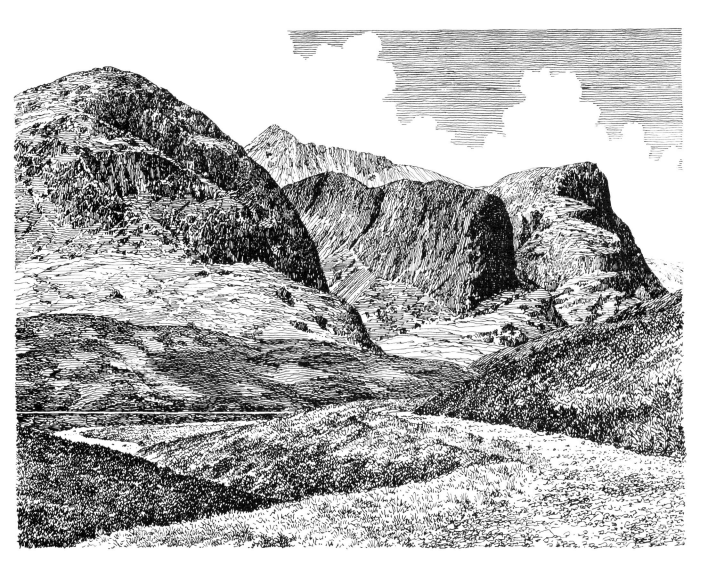

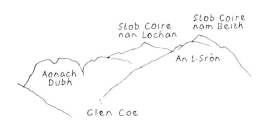

Stob Coire nam Beith

Stob Coire nan Lochan

An t-Sròn

Aonach Dubh

Glen Coe

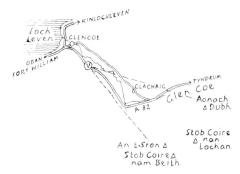

KINLOCHLEVEN

Loch Leven

GLENCOE

OBAN
FORT WILLIAM

CLACHAIG

TYNDRUM

Glen Coe

Aonach Dubh

A.82

Stob Coire nan Lochan

An t-Sròn
Stob Coire nam Beith

191 The western outliers
of Bidean nam Bian

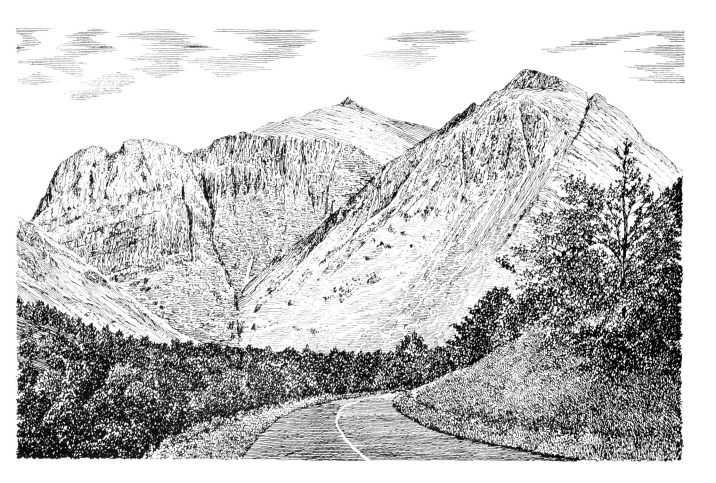

Stob Coire nam Beith, a close subsidiary of the summit of Bidean nam Bian, exhibits impressive proportions to the road in Glen Coe near Loch Achtriochtan.

192 Stob Coire nam Beith, 3621'
(peak of the corrie of the birch trees)

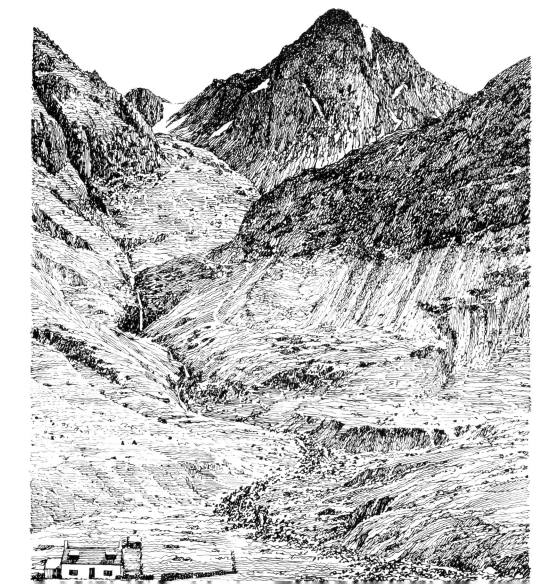

1: Aonach Dubh
2: Stob Coire nan Lochan
3: Stob Coire nam Beith
4: Bidean nam Bian
5: An t-Sròn

Glen Coe

FORT WILLIAM ← A.82
NORTH BALLACHULISH
OBAN ← A.828
Loch Leven
KINLOCHLEVEN
KINLOCHLEVEN
GLENCOE
BALLACHULISH
CLACHAIG
A.82
TYNDRUM →
Glen Coe
Aonach △ Dubh
Stob Coire △ nan Lochan
Stob Coire nam Beith △
Bidean nam Bian ▲

193 Bidean nam Bian, 3766′ (M.23)
(pinnacle of the hides)

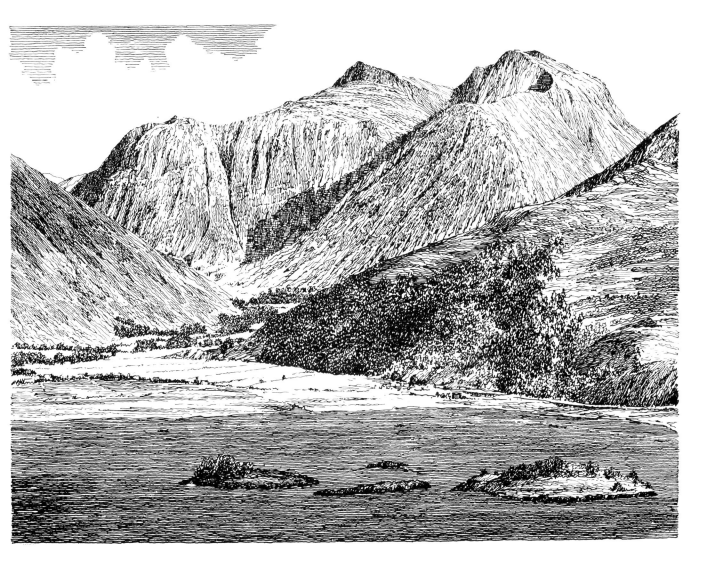

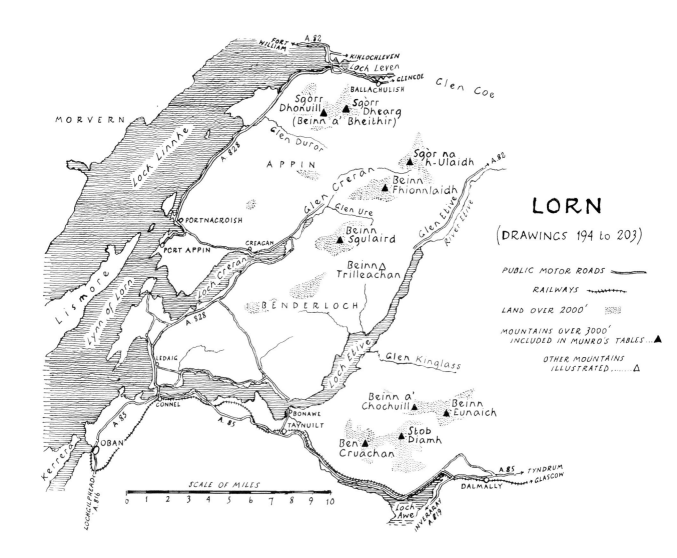

MORVERN

FORT WILLIAM
A 82
KINLOCHLEVEN
Loch Leven
GLINCOE
BALLACHULISH
Glen Coe

Sgòrr Dhonuill ▲ ▲ Sgòrr Dhearg
(Beinn a' Bheithir)

Glen Duror

APPIN

Loch Linnhe

A 828

Glen Creran

Sgòr na h-Ulaidh ▲

Beinn Fhionnlaidh ▲

A 82

Glen Ure

PORTNACROISH

CREAGAN

Beinn Sgulaird ▲

Glen Etive

River Etive

PORT APPIN

Loch Creran

Beinn Trilleachan △

Lismore

Lynn of Lorn

A 828

BENDERLOCH

Loch Etive

LEDAIG

Glen Kinglass

Beinn a' Chochuill ▲ ▲ Beinn Eunaich

CONNEL

A 85

BONAWE

TAYNUILT

A 85

Stob Diamh ▲

Ben Cruachan ▲

OBAN

Kerrera

LOCHGILPHEAD
A 816

A 85

TYNDRUM
GLASGOW

DALMALLY

Loch Awe

INVERARAY
A 819

LORN

(DRAWINGS 194 to 203)

PUBLIC MOTOR ROADS

RAILWAYS

LAND OVER 2000'

MOUNTAINS OVER 3000'
INCLUDED IN MUNRO'S TABLES ... ▲

OTHER MOUNTAINS
ILLUSTRATED △

SCALE OF MILES

0 1 2 3 4 5 6 7 8 9 10

Lorn is a district of Argyll. Mainly maritime, it includes the long and indented coastal area extending from Loch Craignish to Loch Leven, with Oban the only town, and has a wide strip of hinterland bounded by Loch Awe and the Black Mount. The scenery is richly varied, alike only in its high quality. The loveliness and charm of the island-studded seaboard and winding lochs contrasts with the grandeur of the peaks but every natural scene is pleasant to look upon. Beauty takes many forms. Here, in Lorn's diverse landscape, they are all present.

The upland area is centred mostly around Loch Etive, a sinuous sea-water channel that penetrates deeply into the mountains. Between it and the western coastline are the peninsulas of Appin and Benderloch, places of history and legend and the setting of R.L.Stevenson's Kidnapped, each having a cluster of high peaks of which the greatest is Beinn a' Bheithir (Ben Vair), soaring above the inlet of Loch Leven. A trinity of lofty heights flanks the quiet and unspoilt Glen Creran.

The grandest mountain in Lorn south of Glen Coe, however, is Ben Cruachan, one of the best known and most popular of Scottish mountains although revealing its finest features only to those who accept its challenge. It dominates the northern reaches of Loch Awe and is skirted by a road and a railway familiar to Oban-bound tourists, and is also the scene of a recent engineering enterprise that itself attracts visitors. The ramifications of Ben Cruachan are immense, and its topography, a succession of peaks linked by high ridges and supported by massive buttresses, is a complex pattern providing rewarding adventures for explorers of high places.

Although the mountainous areas are uninhabited, there is no lack of accommodation for tourists around the fringes. Dalmally and Taynuilt are holiday resorts in their own right, and scattered along the coastal roads are many hotels and caravan sites. And, of course, there is Oban, a convenient centre for excursions both on land and sea, and increasingly dedicated to the welfare of visitors.

Beinn a' Bheithir (pronounced Ben Vair)
is an imposing cornerstone of Appin overlooking
the meeting of Lochs Leven and Linnhe, towering
boldly above a skirt of new plantations.
Sgòrr Dhearg is the higher of the two
main peaks on the summit-ridge.

194 Sgòrr Dhearg, 3362' (M.103)
(red peak)
Beinn a' Bheithir
(peak of the thunderbolt?)

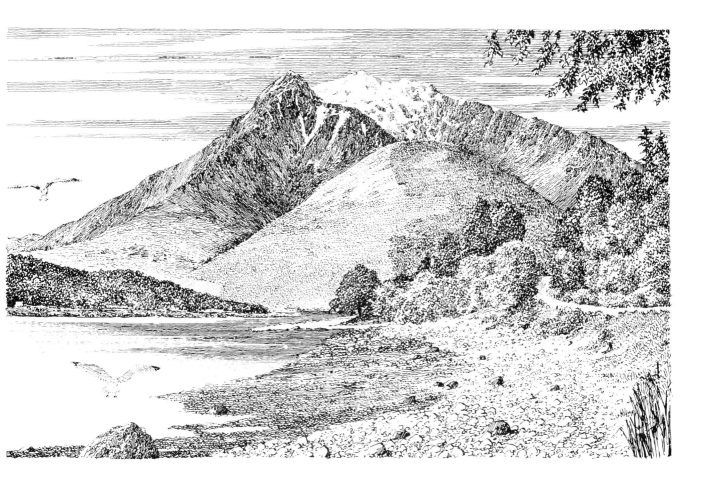

Sgòrr Dhonuill is the lower of the two peaks of Beinn a' Bheithir and is especially well seen from the north side of the narrows of Loch Leven, where motorists waiting for the Ballachulish ferry often had ample time to study it. The ferry was superseded by a bridge in 1975 and with it has gone the charm of the crossing. There is no romance in concrete.

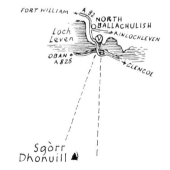

195 Sgòrr Dhonuill, 3284′ (M. 127)
(Donald's peak)

Beinn a' Bheithir
(peak of the thunderbolt?)

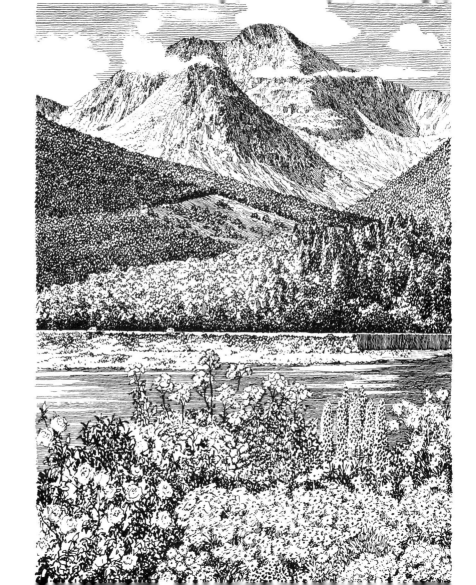

The praises of Glen Creran have not been
sung enough. This is a lovely valley, notable
for a wealth of noble trees. Where the glen
turns east, at Salachail, the shapely peak of
Sgòr na h·Ulaidh comes into view in isolation.

196 Sgòr na h-Ulaidh, 3258'
(peak of the hidden treasure) (M.144)

Sgòr na
h-Ulaidh

SALACHAIL

River Creran

GLENURE

Glen Creran

A 828

FORT
WILLIAM

Loch
Creran

OBAN A 828

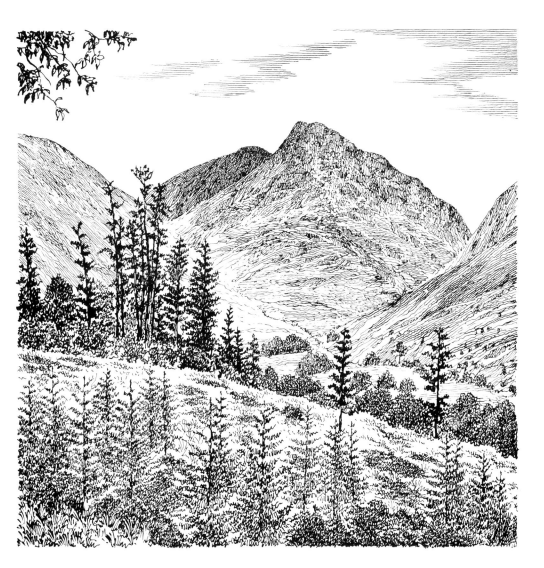

Beinn Fhionnlaidh is prominent throughout the walk along
Glen Creran, forming a bulky wedge on the east side between
the main valley and Glen Ure, where lived Colin Campbell
(the Red Fox), whose murder in 1752 remains a mystery
although a Stewart was hanged for the crime.
 The mountain takes better shape from the track above
Salachail, where the distant summit comes into view.

197 Beinn Fhionnlaidh, 3139'
 (Finlay's mountain) (M. 197)

SALACHAIL

▲ Beinn
Fhionnlaidh

River Creran

GLENURE

Glen Creran

A 828

FORT
WILLIAM

Loch
Creran

A 828

OBAN

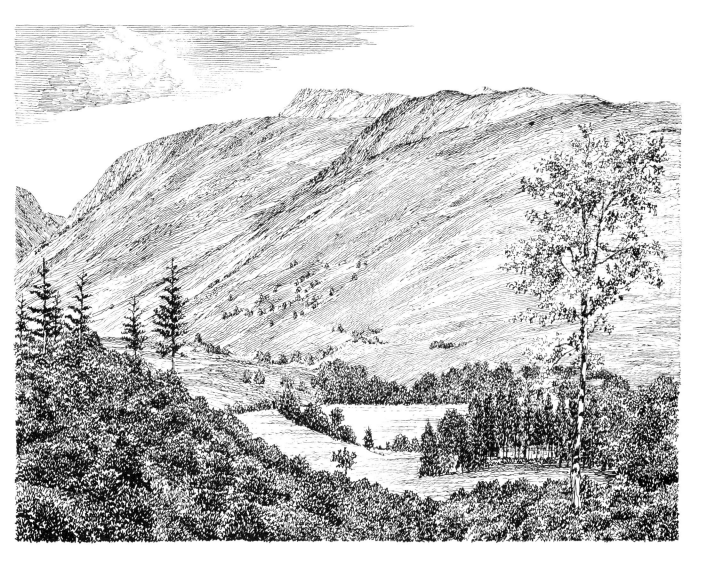

The most prominent of the Benderloch mountains
is Beinn Sgulaird, which dominates the road
rounding the head of Loch Creran and the
first three miles of the valley leading
therefrom into the hills.

(M.239)

198 Beinn Sgulaird, 3059'

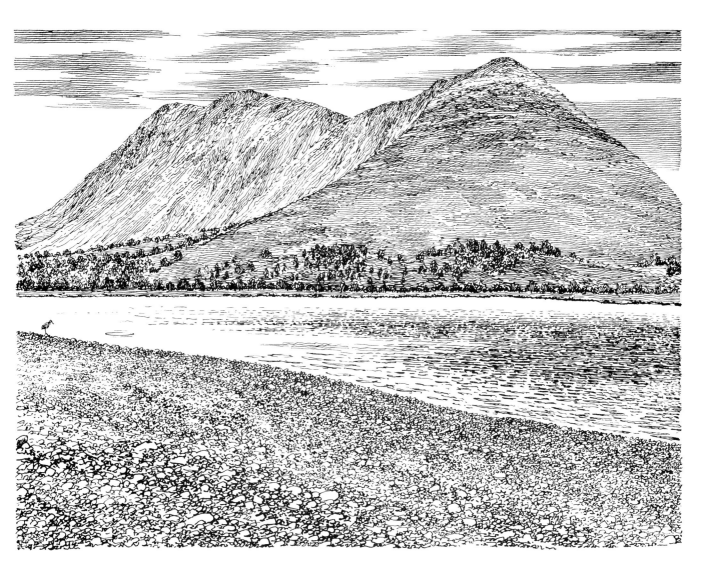

Rather dwarfed by the other mountains around Loch Etive
but starkly impressive when seen at close quarters, Beinn
Trilleachan's main attraction (for rock climbers) is the
great sweep of naked slabs falling from the craggy
upper slopes to the lochside.

199 Beinn Trilleachan, 2752'
(mountain of sandpipers)

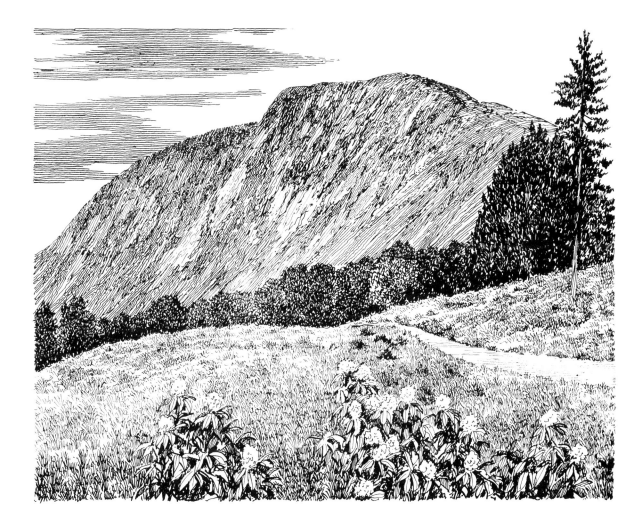

Ben Cruachan is one of the giants of the
Highlands, not for its lofty altitude alone
but mainly because of its massive bulk and
sequence of airy peaks and ridges. Its
commanding position overlooking Loch
Awe and popular tourist routes have
made the name familiar to many. In
recent years it has suffered, with benevolent
indifference, the construction of a hydro-electric
storage station on a large scale, with underground
galleries and tunnels hewn out of the lower slopes
and a new reservoir in a high corrie for it to weep in.
But mere man cannot rob Ben Cruachan of its majesty.

▲ Ben Cruachan

Cruachan
Reservoir

OBAN

LOCHAWE

A 85

DALMALLY
GLASGOW

A 819

Loch
Awe

INVERARAY

200 Ben Cruachan, 3689' (M.29)
(mountain of peaks, or stacks)

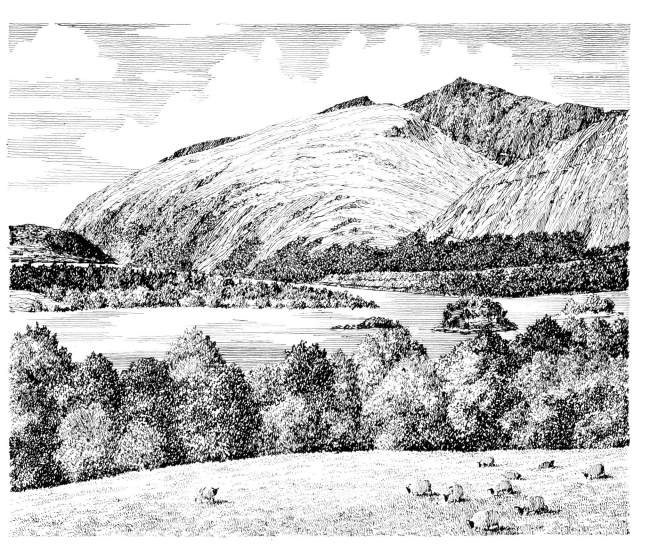

The main ridge of Ben Cruachan has an east-west axis
but at Stob Diamh, at the east end, divides into a great
hollow horseshoe facing Glen Strae. Stob Diamh
has, rather arbitrarily, been deemed a Munro
but can hardly properly be considered a
separate mountain. It is an integral part
of the topographical build-up of Ben Cruachan.

Stob ▲
Diamh

201 Stob Diamh, 3272' (M. 137)
(peak of the stags)
Ben Cruachan.

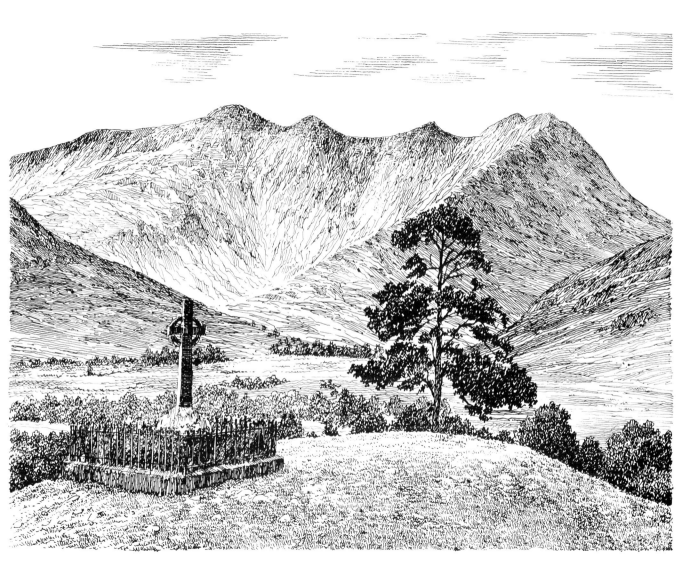

Beinn a' Chochuill shelters behind Ben Cruachan and appears insignificant by comparison. It is in view around the confluence of the Rivers Orchy and Strae and is also well seen from the middle reaches of Loch Etive.

202 Beinn a' Chochuill, 3215' (M.163)
(mountain of the hood)

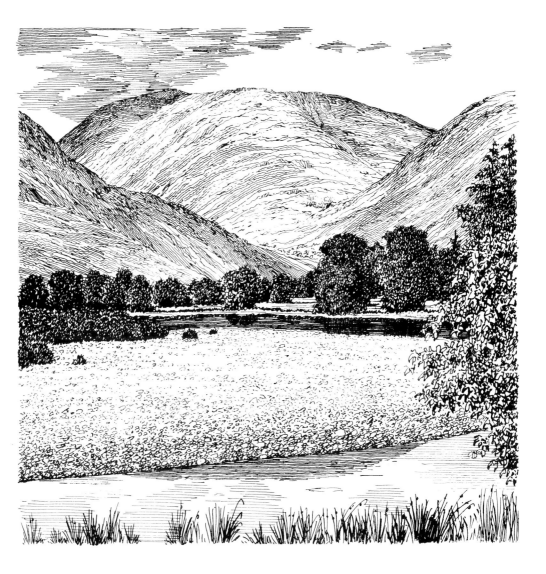

Beinn Eunaich is prominently in view from the
wide Strath of Orchy where the river of that name
joins the Strae and enters Loch Awe. Nearby, on a
promontory of the loch, stand the gaunt ruins of
Kilchurn Castle, built in 1440.

203 Beinn Eunaich, 3242' (M. 149)
(fowling peak)

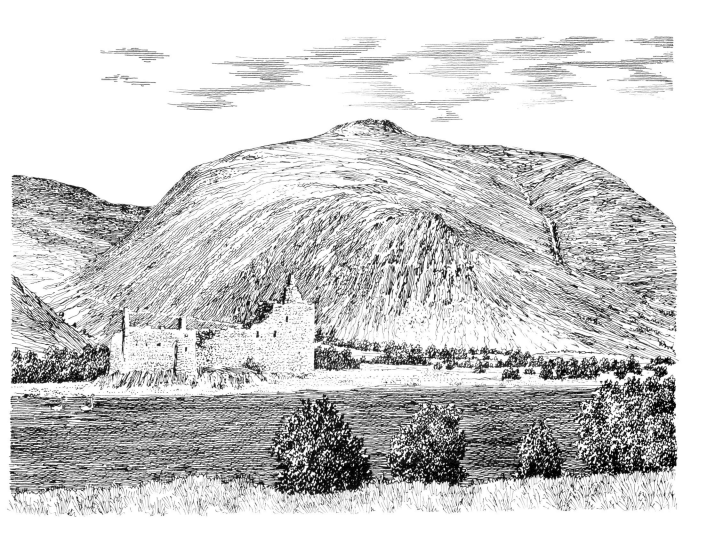

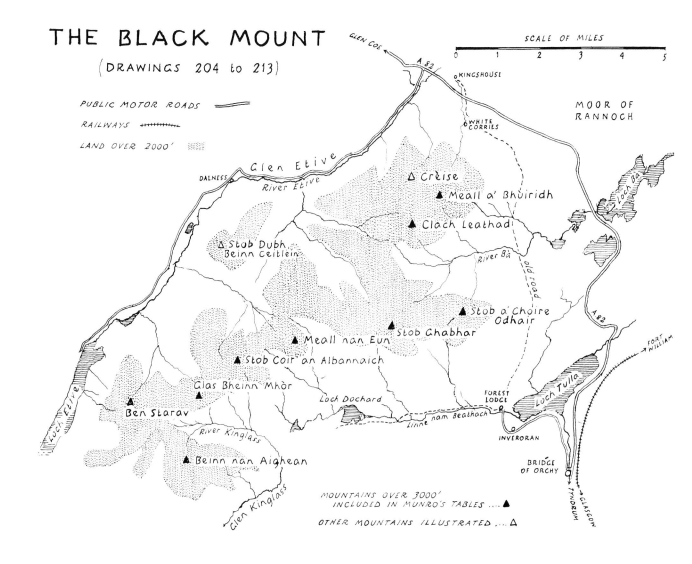

THE BLACK MOUNT

(DRAWINGS 204 to 213)

PUBLIC MOTOR ROADS

RAILWAYS

LAND OVER 2000'

SCALE OF MILES

0 1 2 3 4 5

GLEN COE

A 82

KINGSHOUSE

MOOR OF RANNOCH

WHITE CORRIES

Glen Etive

DALNESS

River Etive

△ Crèise

▲ Meall a' Bhùiridh

▲ Clach Leathad

△ Stob Dubh
Beinn Ceitlein

River Bà

old road

Loch Bà

A 82

▲ Stob a' Choire Odhair

▲ Stob Ghabhar

▲ Meall nan Eun

▲ Stob Coir an Albannaich

Glas Bheinn Mhòr

Loch Dochard

FOREST LODGE

Loch Tulla

FORT WILLIAM

▲ Ben Starav

River Kinglass

Linne nam Beathach

INVERORAN

Loch Etive

▲ Beinn nan Aighean

BRIDGE OF ORCHY

TYNDRUM

GLASGOW

Glen Kinglass

MOUNTAINS OVER 3000'
INCLUDED IN MUNRO'S TABLES ▲

OTHER MOUNTAINS ILLUSTRATED △

The Black Mount is, properly, the moorland rising north of Loch Tulla, but the name is generally applied, conveniently but not quite correctly, to the well-defined group of peaks towering westwards and extending to the deep rift of Glen Etive. These mountains are displayed with great effect to the popular road A.82 across Rannoch Moor, which enjoys a grandstand view of them, and, on a journey with many highlights, form the most magnificent prospect of all south of Glen Coe, the scene being enhanced by a succession of lovely lochs in the foreground. Few travellers with cameras pass along here without halting. Some halt every time they make the journey, the scene being especially sensitive to atmospheric and climatic changes and rarely presented in quite the same conditions.

The topography of the group is complex, the main ridges having subsidiary spurs that also rise to prominent summits while some of the mountains almost stand in isolation, separated from their fellows by deep corries. But although the detail is complicated the boundaries of the area are simply and clearly defined. The A.82 borders it in the north and east; Glen Etive, in the west, very effectively severs it from the mountains of Glen Coe and Benderloch, and the southern base of the triangle is formed by Glen Kinglass and a low pass that leads by Loch Dochard to Loch Tulla. Within these boundaries is a wild tangle of mountains, deeply etched by watercourses and corries into individual peaks. At least four of the mountains in this fine array are fit to rank in the company of the great: Ben Starav, Stob Coir' an Albannaich, Clach Leathad, Stob Ghabhar.

Access to the group is best gained not from a single base but from a variety of points around the perimeter. Forest Lodge, to which cars may be taken, is a convenient springboard for expeditions in the south; the old road to Glen Coe (not for cars), which links Forest Lodge and White Corries, follows a line close to the foot of the Clachlet range and is to be preferred to cross-country routes from the A.82; and from the public road in Glen Etive there are short but very steep approaches to the western summits. Apart from a private climbing hut near Forest Lodge the interior is without habitations, and if accommodation is desired recourse must be made to the three hotels at Inveroran, Bridge of Orchy, and Kingshouse.

The Black Mount is a region to make the strong in limb exultant, and old men weep for their lost youth. But all, of any age, climbers or not, with or without cameras, must surely admire the wonderful picture they see across the heathery wastes of Rannoch Moor.

Ben Starav is the great overlord of Loch Etive, impending above the water in formidable slopes that fall directly from the peaked summit. This is a magnificent mountain, the top being the hub of converging ridges like the spokes of a wheel.

204 Ben Starav, 3541' (M.59)
(strong mountain)

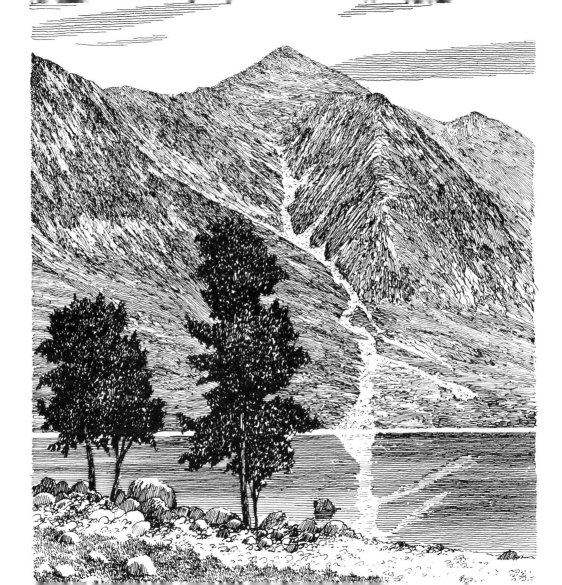

Overshadowed by the nearby Ben Starav, and suffering by
comparison, Beinn nan Aighean is remotely situated at the
head of Glen Kinglass, into which all its waters drain.
It is best viewed, however, from the
vicinity of Loch Dochard on the walk
from Forest Lodge.

Loch Dochard

FOREST
LODGE

Linne nam Beathach

Loch Tulla

A 82

GLEN COE

FORT WILLIAM

INVERORAN

▲ Beinn nan Aighean

BRIDGE
OF ORCHY

GLASGOW

TYNDRUM

205 **Beinn nan Aighean, 3141′ (M.193)**
(Beinn nan Aighenan) (mountain of the hinds)

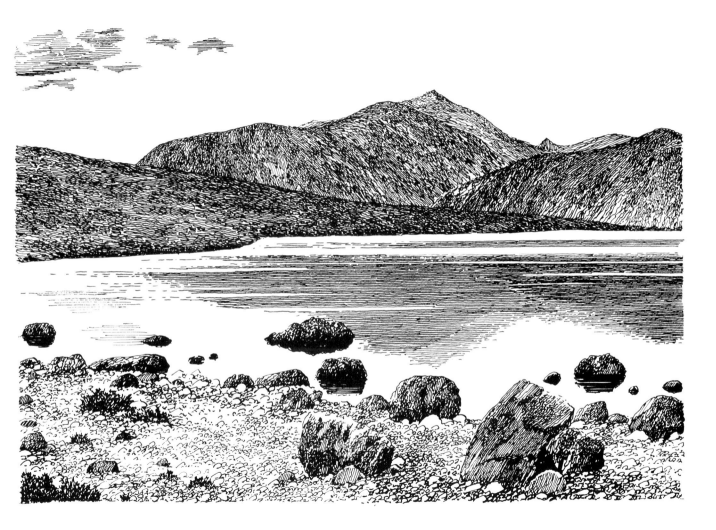

The mountains bordering Glen Etive are characterised
by exceedingly rugged slopes and crowd the valley so
closely that their summits are hidden or foreshortened
and lack shapeliness. At one point, however, there is an
unrestricted view up the side-valley of the
Allt Mheuran, revealing, at its head, the
graceful cone of Glas Bheinn Mhòr.

206 Glas Bheinn Mhòr, 3258' (M.145)
(big grey mountain)

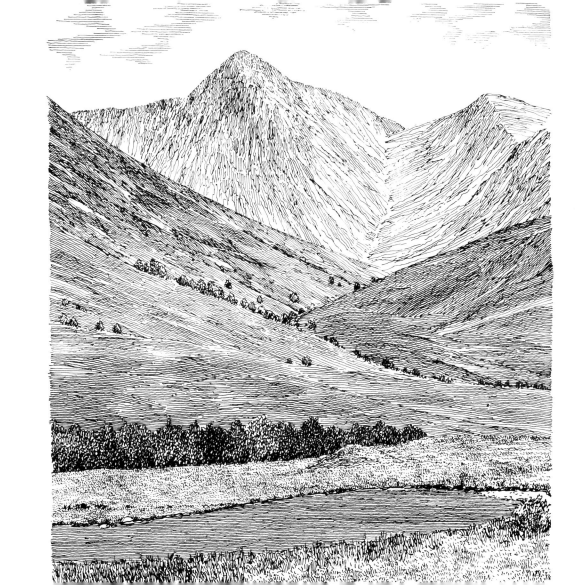

Loch Dochard, reached by a good path from Forest Lodge,
lies in an amphitheatre ringed by mountains, of which
the abrupt peak of Stob Coir' an Albannaich
most compels the eye.

Meall nan Eun ▲

Stob Coir' ▲
an Albannaich

Loch
Dochard

FOREST
LODGE

Linne nam Beathach

INVERORAN

Loch Tulla

GLEN
COE

A 82

→ FORT WILLIAM

BRIDGE
OF ORCHY

→ TYNDRUM

→ GLASGOW

207 Stob Coir' an Albannaich, 3425' (M.84)
(peak of the corrie of the Scotsman)
and
Meall nan Eun, 3039' (M. 254)
(hill of the birds)

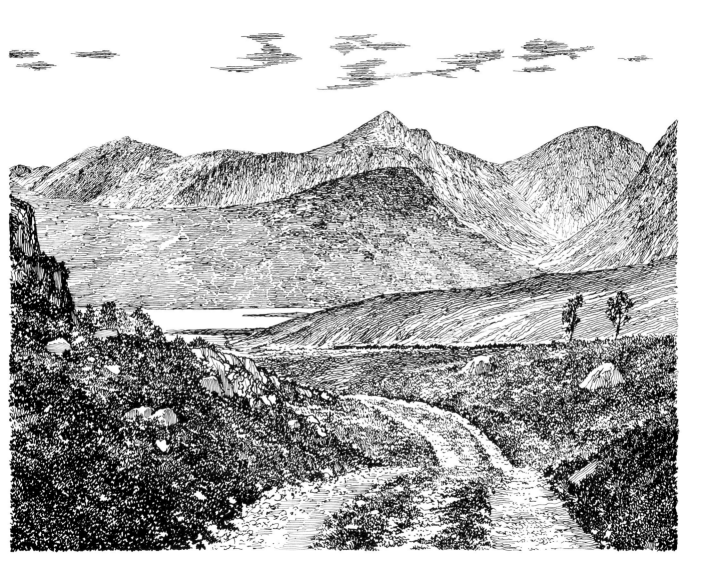

Although surrounded by higher mountains, Beinn Ceitlein commands the attention of travellers in Glen Etive by reason of its fierce aggressiveness, the northern slopes being broken by fearful crags and the southern aspect revealing a huge rift splitting the mountain below the highest summit, Stob Dubh.

208 Stob Dubh, Beinn Ceitlein, 2897'

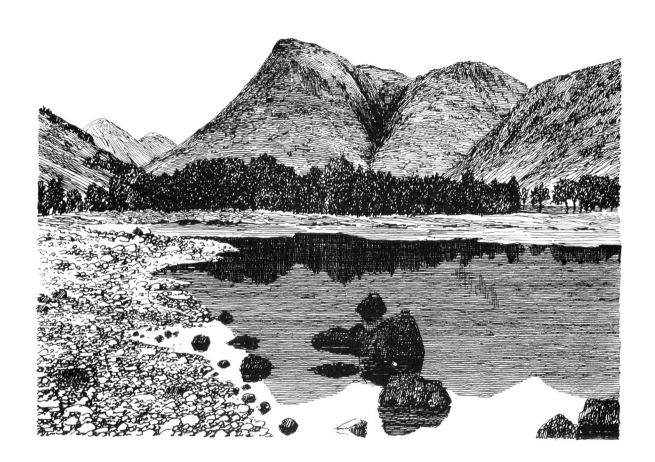

Looking every inch a Munro but disqualified as such because it is deemed to be only a part of Clach Leathad and not a separate mountain, Crèise abruptly terminates the Black Mount in the north by displaying a facade of steep cliffs to Rannoch Moor near Kingshouse.

209 Crèise, 3596'

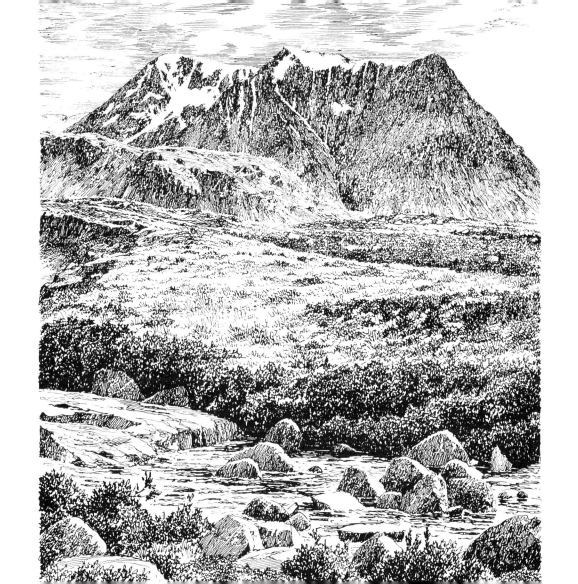

Meall a' Bhùiridh is the highest of the Black Mount peaks
but until recently, despite its prominence overlooking Rannoch
Moor, did not find as much favour in the itineraries of mountaineers
as others in the group. Today it is a place of popular resort, an
amiable and long-lasting snow-slope on the northern flank
having been developed for skiing by the provision of a
chair-lift and a ski-tow. Members of the general public
can join in the fun. The centre is known as White Corries.

210 Meall a' Bhùiridh, 3636' (M.42)
(hill of the roaring (stags))

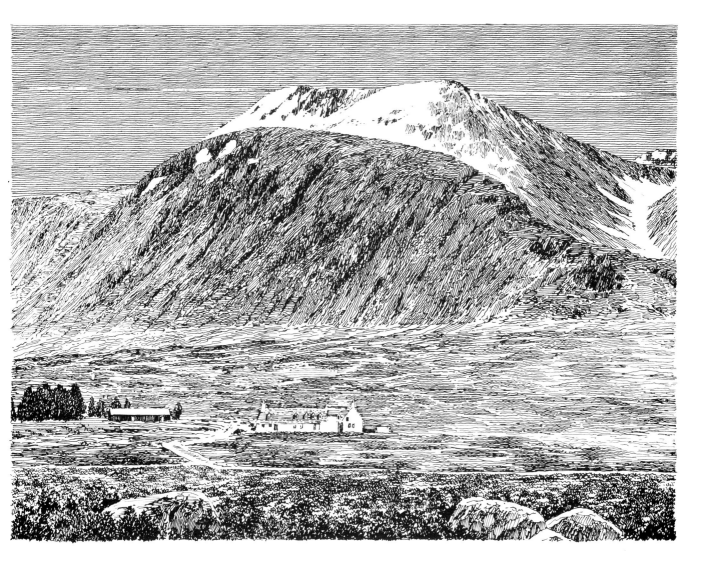

Affectionately known as Clachlet, this mountain and its associated ridges together provide an expedition of great merit over interesting terrain with superb views. A hint of its promise is glimpsed from the A.82 near Loch Bà.

Clach ▲
Leathad

GLEN COE ◄
A.82
Loch Bà
BRIDGE OF ORCHY

211 Clach Leathad, 3602' (M.49)
(Clachlet) (stony slope)

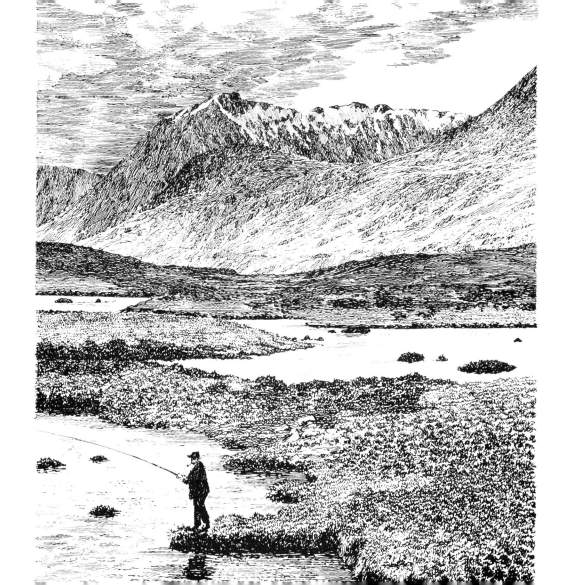

Travelling north on the A.82 from Bridge of Orchy
the nearest (and least attractive) of the Black Mount
heights is Stob a' Choire Odhair, but not until
Loch Bà is reached is its best feature brought
into view, this being a precipitous declivity
falling into the profound depths of Coire Bà.

Stob a'
Choire ▲
Odhair

GLEN COE

A 82

BRIDGE OF ORCHY

212 Stob a' Choire Odhair, 3058' (M.240)
(peak of the dun corrie)

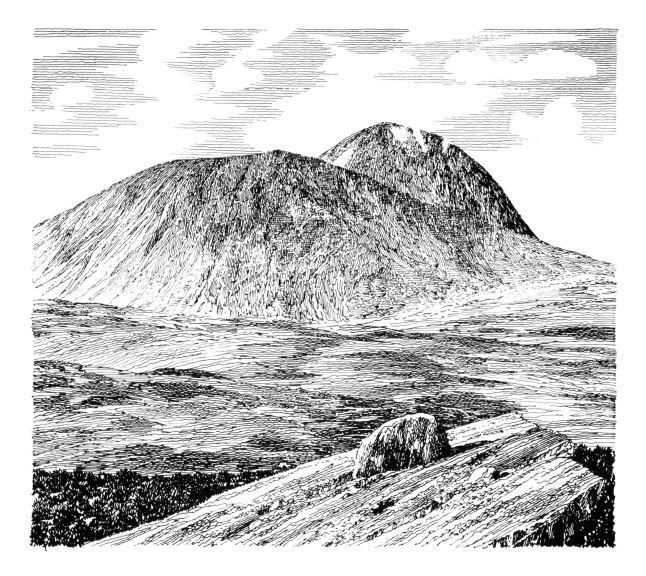

▲ Stob Ghabhar

When snow is lying on the Black Mount, a strong
contrast is provided by the pinewoods of Loch Tulla,
which, in such conditions, frame Stob Ghabhar beautifully.
This is a mountain of considerable extent and complexity
with several subsidiary summits and two long and lofty
ridges descending north-west towards Glen Etive.

213 Stob Ghabhar, 3565′ (M.54)
(peak of the goats)

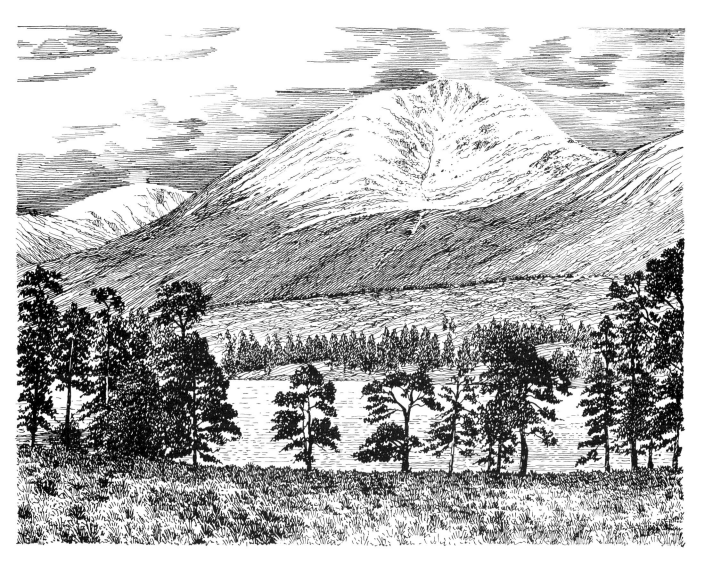

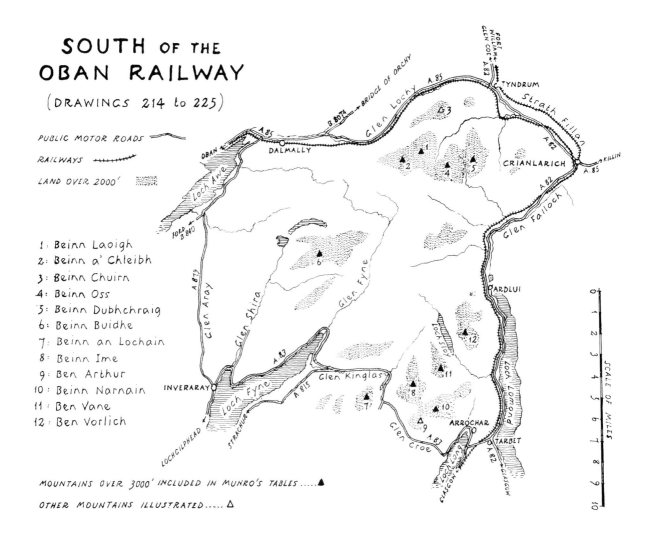

SOUTH OF THE OBAN RAILWAY

(DRAWINGS 214 to 225)

PUBLIC MOTOR ROADS

RAILWAYS

LAND OVER 2000'

1: Beinn Laoigh
2: Beinn a' Chleibh
3: Beinn Chuirn
4: Beinn Oss
5: Beinn Dubhchraig
6: Beinn Buidhe
7: Beinn an Lochain
8: Beinn Ime
9: Ben Arthur
10: Beinn Narnain
11: Ben Vane
12: Ben Vorlich

MOUNTAINS OVER 3000' INCLUDED IN MUNRO'S TABLES ▲

OTHER MOUNTAINS ILLUSTRATED △

SCALE OF MILES

0 1 2 3 4 5 6 7 8 9 10

Undulating terrain of outstanding beauty extends southwards from the line of the Oban railway to the Firth of Clyde and westwards to the Atlantic seaboard, the diverse landscape being almost severed by the lovely Loch Awe and deeply indented by long and narrow sea-lochs that penetrate far into the interior: a maritime area that quickly builds up into ranges of mountainous country; an intermixing of land and water, complex in pattern yet gloriously fashioned in a wide variety of textures and colours. For the most part the gradients of the hills are gentle and they are of no great height, but there are two groups of mountains of special distinction, the first centred on Beinn Laoigh in the angle formed where the railway turns south to Loch Lomond, the other around the head of Loch Long.

Beinn Laoigh, more often referred to as Ben Lui, is the highest mountain in the region and the grandest, rising supremely to a delicately-etched double summit, and overtopping a cluster of satellites that are also of Munro status but quite subservient. Ben Lui is the undisputed monarch here and a superb example of mountain architecture. Men may corrupt the name but not the mountain.

Around the head of Loch Long are several worthy giants collectively known unofficially but appropriately as the Arrochar Alps. Easy access from Glasgow has ensured their continuing and increasing popularity with climbers, while the nature of the terrain — a labyrinth of rocky outcrops, crags, boulders and even caves — makes them a fine adventure ground for city dwellers. The peak best known and most loved is Ben Arthur, The Cobbler, recognisable on sight by its tortured summit outline. Sadly, this group of hills has suffered indignities at the hand of man: pylons sprout like weeds on the lower slopes, hydro-electric works stand naked and unashamed where heather once grew, dark rectangles of regimented conifers choke the natural vegetation, and even the loch is exploited by marine and naval operators. The tops are free from commercial interference but the approaches are a sorry example of the damage that can be caused when man leaves amenity values out of his priorities.

There is no lack of accommodation for visitors in the inhabited districts, this being supplemented by camping and caravan sites. For quick access to most of the higher mountains Tyndrum and Arrochar are the best bases, the railway providing a convenient link between them.

Of majestic appearance, and bearing a mantle of snow for much of the year, Ben Lui has often been likened to an Alpine peak and is a popular venue for winter climbing. It is a dominating object in the landscape of Glen Lochy but the classic view of this noble mountain is obtained on the usual approach via Coninish from Tyndrum (Oban line) Station.

There are 24 higher mountains in Scotland but few more handsome.

214 Beinn Laoigh, 3708′ (M.25)
(Ben Lui) (mountain of the calf)

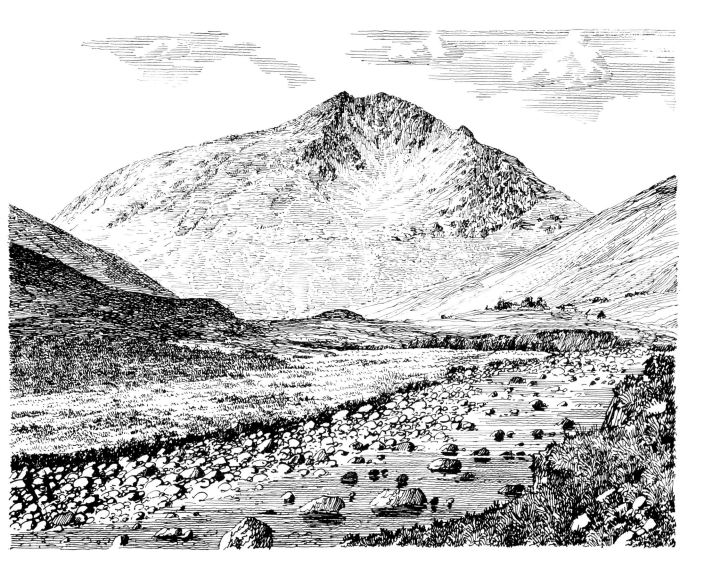

Beinn a' Chleibh is a rounded hill prominently
in view from the road and railway in Glen Lochy,
whence it appears to be more in the nature of
a buttress to Ben Lui (on the left
of the drawing) than a mountain
with a separate identity.

215 Beinn a' Chleibh, 3008' (M. 272)
(mountain of the chest (or creel?)

Beinn Chuirn is the only one of the peaks around the Coninish basin that does not rank as a Munro, but is a fine mountain nevertheless. It gets less attention than it deserves, being invariably by-passed by walkers bound for Ben Lui.

216 Beinn Chuirn, 2878'

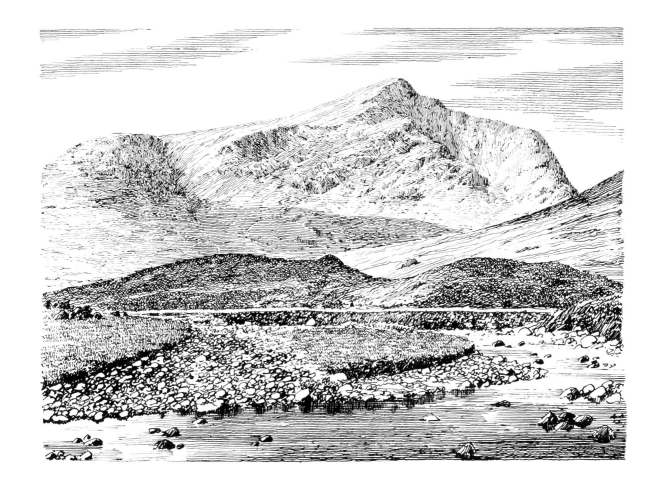

Beinn Oss is less obtrusive than its neighbours, remaining hidden behind Beinn Dubhchraig on the Coninish approach until revealed by a bend in the valley as a steep pyramid of grassy slopes crowned by a rampart of crags.

217 Beinn Oss, 3374′ (M.99)
(mountain of the elk)

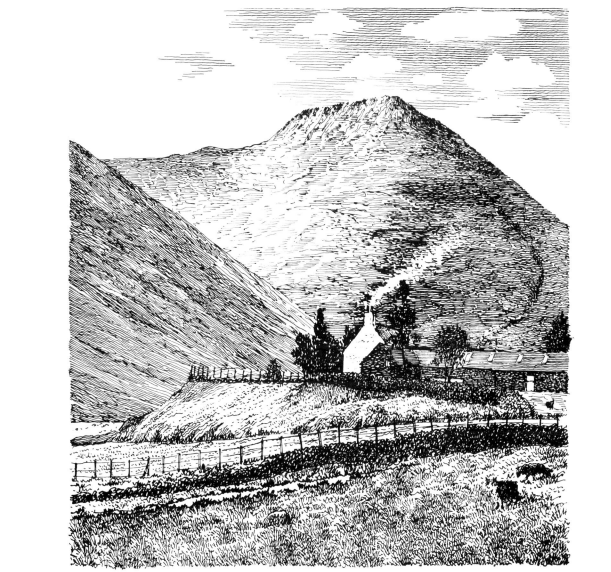

Beinn Dubhchraig is the most conspicuous of the
Tyndrum heights in view from the A.82 road, being
seen rising sharply behind a wooded foreground (the
site of a battle in 1306) where the Oban railway
makes a wide loop to avoid terrain much cut up
by the attractive Coninish river.

Beinn Dubhchraig

218 Beinn Dubhchraig, 3204'
(mountain of the black rock) (M.168)

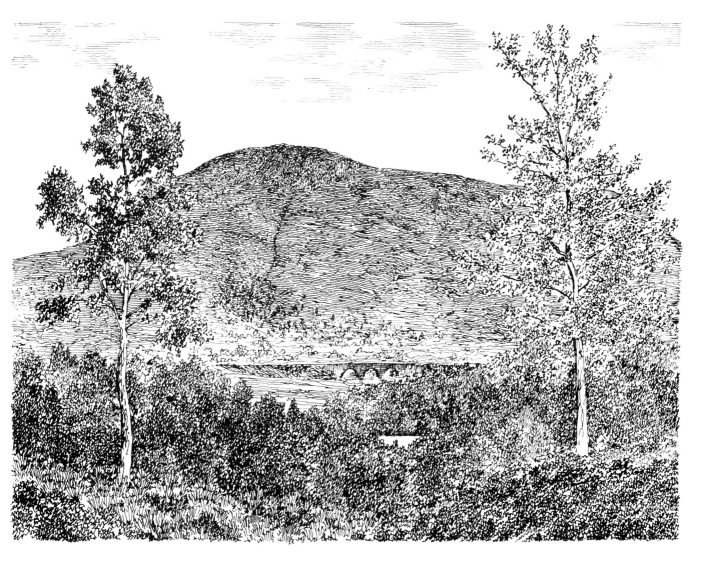

Beinn Buidhe stands in isolation away from
other Munros and is the focal point of the upland
deer forest rising between Glen Shira and Glen Fyne,
from neither of which valleys, however, is it seen
comprehensively because of its immense bulk.
There is a distant view from Inveraray.

219 Beinn Buidhe, 3106′ (M.211)
(Beinn Bhuidhe) (the yellow mountain)

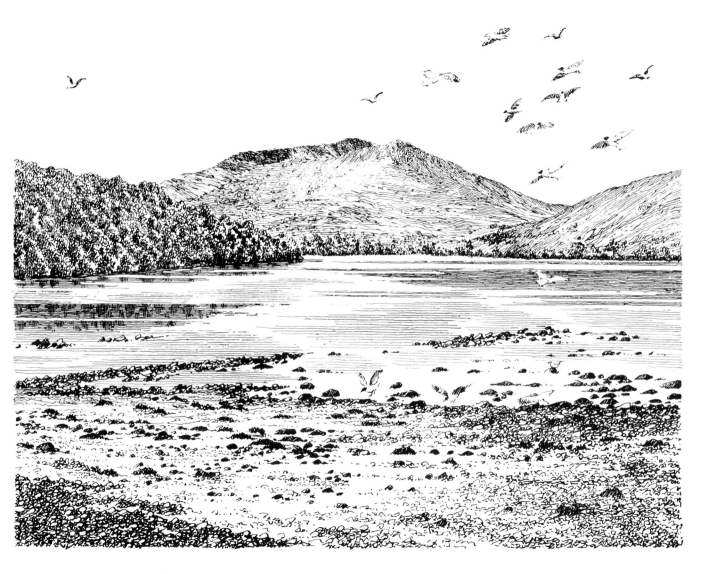

All the Arrochar hills are rough and steep and craggy, none more so than Beinn an Lochain, which presents a formidable aspect on all sides and thrusts aggressively into Glen Kinglas, shadowing the road at its base.

220 Beinn an Lochain, 3021' (M.263)

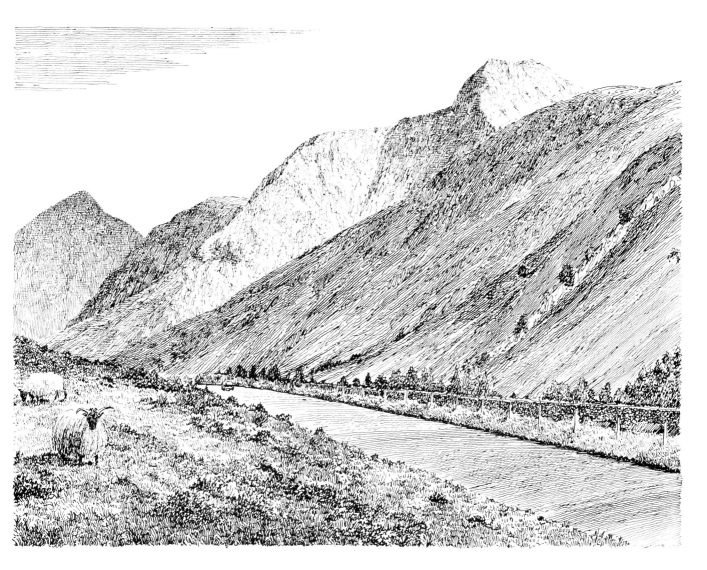

Beinn Ime, the loftiest of the Arrochar
group of mountains, stands directly ahead
on the western approach to Glen Kinglas,
rising as a splendid cone and seeming to
bar exit from the valley, the road being
forced south to the 'Rest and be thankful'
pass.

221 Beinn Ime, 3318' (M.113)
(butter mountain)

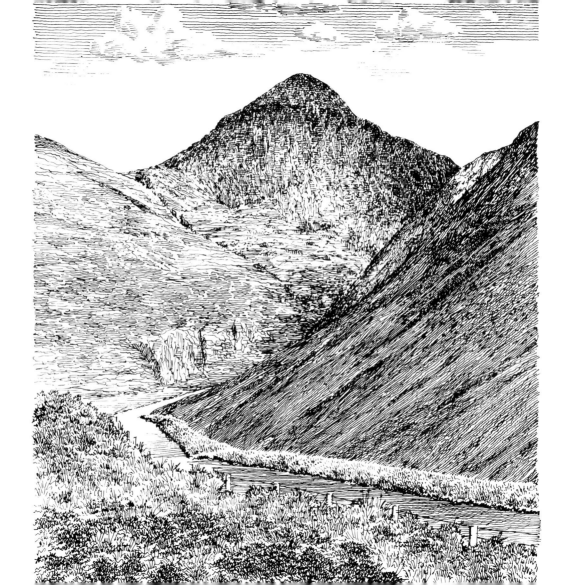

The West Highland Railway provides a
succession of grandstand mountain views,
an example being on the long gradient
above Loch Long, where the carriage windows
frame a splendid picture of Ben Arthur
(much better known as The Cobbler) and
a near companion, Beinn Narnain.

222 Ben Arthur, 2891'
(The Cobbler)
and
Beinn Narnain, 3036' (M.256)

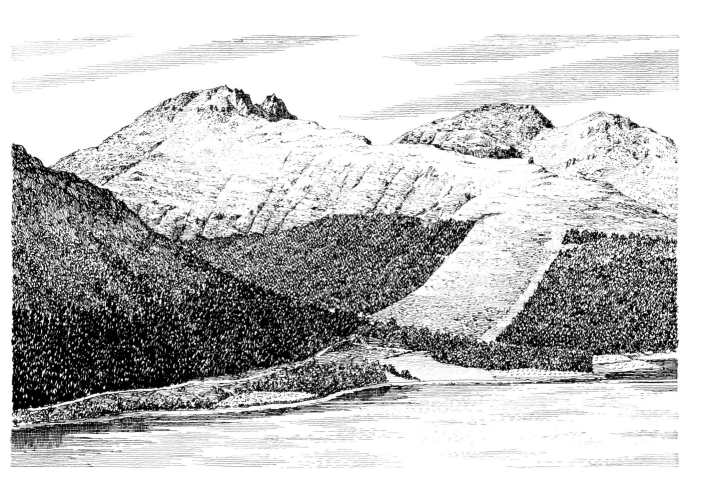

The Cobbler gets its popular name from the grotesque rocks forming the summit, local imaginative minds having fancied a resemblance in the silhouette to a shoemaker bending over his last. This is a well-known and much frequented climbing ground, the actual summit, an upstanding rock, being attained only by gymnastic effort.

223 The summit of Ben Arthur

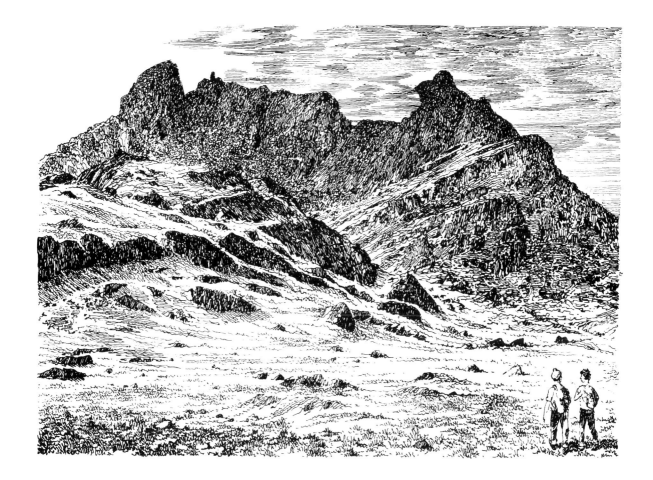

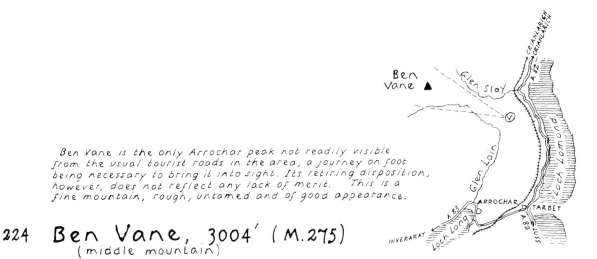

Ben Vane is the only Arrochar peak not readily visible from the usual tourist roads in the area, a journey on foot being necessary to bring it into sight. Its retiring disposition, however, does not reflect any lack of merit. This is a fine mountain, rough, untamed and of good appearance.

224 Ben Vane, 3004′ (M.275)
(middle mountain)

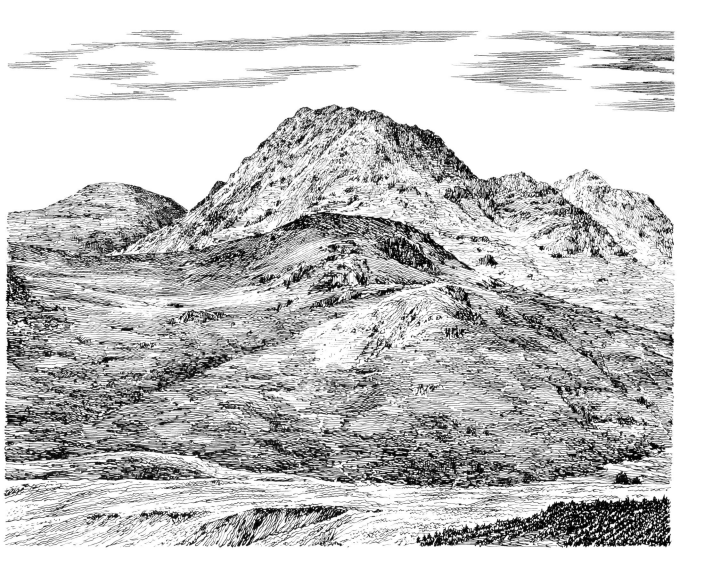

Man has not dealt kindly with Ben Vorlich, disfiguring it with hydro-electric works, a dam and a road and a tunnel, naked pipelines, a network of pylons and areas of afforestation. Ben Vorlich, towering over the head of Loch Lomond, is nowadays best appreciated from a distance.

225 Ben Vorlich, 3092' (M.220)

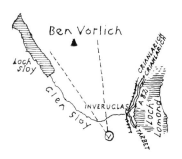

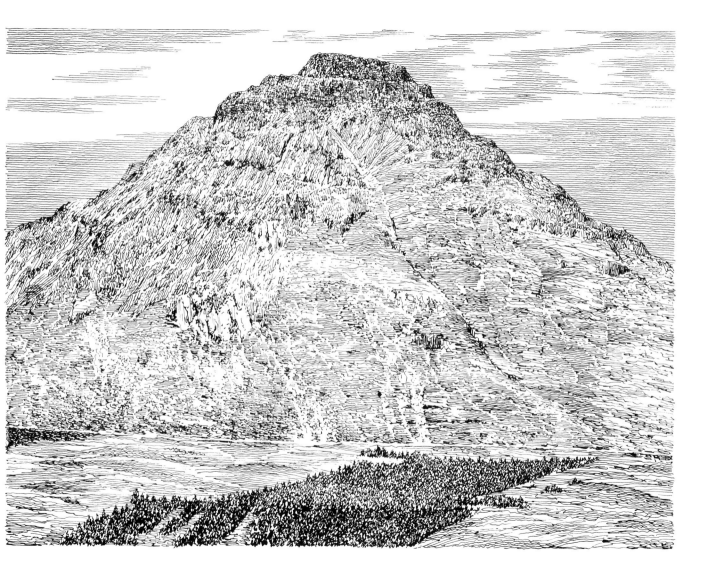

A. WAINWRIGHT

Born in Blackburn in 1907, Alfred Wainwright left school at the age of thirteen. A holiday at the age of twenty-three kindled a life-long love affair with the Lake District. After moving to Kendal in 1941 Wainwright devoted every spare moment he had from then until 1966 to researching and compiling his remarkable Pictorial Guides to the Lakeland Fells.

Five volumes of Wainwright's intricate pen-and-ink drawings of Lakeland scenery were published in the late sixties and early seventies. Twenty-four more volumes of drawings of landscapes in England, Scotland and Wales followed, including this collection and five further volumes of Scottish Mountain Drawings.

A. Wainwright lived to see his Pictorial Guides to the Lakeland Fells achieve sales he never dreamed of when he set out on his labour of love, as he called it. He died in 1991, at the age of eighty-four.

THE WAINWRIGHT SOCIETY

Set up in 2002 to celebrate the work of Wainwright, the Society publishes a quarterly newsletter and organises an annual Memorial Lecture by a guest speaker. There are also monthly walks in areas covered by Wainwright's books. For full details of events and information on how to become a member, visit www.wainwright.org.uk or write to the Membership Secretary at Kendal Museum, Station Road, Kendal, LA9 4BT.